ROSSETTI

ROSSETTI

David Rodgers

For Helen Langdon

Phaidon Press Limited
Regent's Wharf, All Saints Street, London N1 9PA

Phaidon Press Inc.
180 Varick Street, New York, NY 10014

www.phaidon.com

First published 1996
Reprinted 1998, 2002, 2003
© Phaidon Press Limited 1996

ISBN 0 7148 3341 X

A CIP catalogue record for this book is available from the
British Library

Printed in Singapore

Cover illustrations:
Front: *Monna Vanna*, 1866 (Plate 30)
Back: *La Pia de' Tolomei*, c1868–80 (Plate 34)

The publishers would like to thank all those museum authorities and
private owners who have kindly allowed works in their possession to be
reproduced. Particular acknowledgement is made for the following:
Board of Trustees of the National Museums and Galleries on Mersey-
side; Bridgeman Art Library, London; City of Aberdeen Art Gallery
and Museums Collections; Courtesy of Peter Cormack, William Morris
Gallery, London; Courtesy of Museum of Fine Arts Boston, gift of
James Lawrence; Fogg Art Museum, Harvard University Art Mu-
seums, bequest of Grenville L Winthrop; Royal Commission on the
Historical Monuments of England; Stapelton Collection; STP Photog-
raphy, Cardiff.

Note: All dimensions of works are given height before width.

Rossetti

In the history of English art few painters have achieved the notoriety accorded to Dante Gabriel Rossetti. After his death in 1882 his brother, William Michael (Fig. 1), with admirable industry and an understandably evasive diplomacy, wrote and edited, between 1889 and 1906, volume after volume devoted to Rossetti's life and work. William's partisan account provoked William Holman Hunt (1827–1910) to write his own version of events, *Pre-Raphaelitism and the Pre-Raphaelite Brotherhood*, published in two massive volumes in 1905 and 1906, and ever since Rossetti's work and character have been subject to admiration or denigration by successive authors.

The lack of consensus in Rossetti studies may be explained in part by the complex and paradoxical nature of the man. His name, which in its final form was partially self-invented, is exotically Italian, yet he never visited Italy and was chauvinistically English; he venerated the idea of platonic love but was a notorious womanizer; he extolled brotherhood yet cuckolded one of his greatest friends; and, generous, gregarious and extrovert in youth, he became suspicious, reclusive and depressed in middle age. He was also, like William Blake (1757–1827) who he much admired, a poet as well as a painter, and his verses, which at times seem to be intensely personal, provide biographers with a rich source of information. The poems were also the cause of the two greatest crises of his lifetime, their disinterment from his wife's grave in 1869 and his breakdown following Robert Buchanan's critical attack in 1871. His urge to create was such that he frequently wrote sonnets inspired by his paintings and on occasion painted pictures inspired by his verse; to Rossetti the two arts were united, as he wrote to his friend Gordon Hake in 1870:

> My own belief is that I am a poet (within the limit of my powers) primarily, and that it is my poetic tendencies that chiefly give value to my pictures: only painting being – what poetry is not – a livelihood – I have put my poetry chiefly in that form.

Rossetti's decision, at an early stage in his career, never to exhibit publicly meant that his paintings were largely unevaluated in his own lifetime for lack of opportunity and, after his death the aura of singularity attached to him ensured an interest in his work which saved it, for the most part, from fashionable neglect. He was the first to admit that he found painting difficult and technical dexterity should not be looked for in his pictures; they are however, at their best, highly original, personal and compelling. He is, above all, an imaginative painter and therein lies his poetry.

Gabriel Charles Dante Rossetti was born on 12 May 1828, at 38 Charlotte Street, London. He was the second of the four children, Maria, Gabriel, William and Christina, of Gabriele Rossetti, a political refugee, and his wife Frances Polidori. His baptismal names were distinctly paternal: Gabriel after his father, Charles after his father's

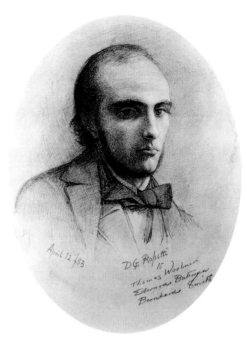

Fig. 1
Portrait of William Michael Rossetti
1853. Pencil on paper, 25.5 x 20 cm.
National Portrait Gallery, London

patron Charles Lyell, and Dante after his father's obsession, the fourteenth-century Florentine poet Dante Alighieri.

Gabriele had arrived in London in 1824, aged 41, having been expelled from Naples for his anti-monarchist political activities. Once in England he made a modest living from teaching and began his studies of Dante. This brought him into contact with Gaetano Polidori, an intellectual Italian émigré, whose daughter Frances he married on 8 April 1826; like her sisters Charlotte and Eliza, Frances was an educated woman, who had trained as a governess. Shortly before his marriage Gabriele published an *Analytical Commentary* on Dante's *Paradiso*, which brought him the friendship and patronage of a wealthy English enthusiast, Charles Lyell, who was to underwrite his later publications. His study of Dante's works, in which he detected a secret political and anti-Catholic allegory, had a profound effect on his eldest son Gabriel, who, in later life, described his father's theories as 'absolutely and hopelessly eccentric and worthless'.

In 1831, when Gabriel was three, his father became Professor of Italian at the recently founded King's College, London. The position was not lucrative, William estimated his father's income at £220–80 a year. However, the intellectual, relaxed and creative atmosphere in this bilingual household more than compensated the children for the absence of wealth. They were all encouraged to exercise their imaginations: reading, writing, drawing and theatricals were taken for granted and further stimuli were provided by the constant stream of visitors, many of them Italian exiles, which ensured lively and heated political and literary discussions.

In 1837, aged nine, Gabriel entered King's College School, where his father, as a professor, was able to obtain reduced fees. He left school in 1841 and by the following summer he had enrolled at Sass's Drawing Academy, the most prominent private art school in London, which counted the infant prodigy John Everett Millais (1829–96) among its recent pupils. There seems to have been no parental opposition to Rossetti's decision to become an artist. He was undoubtedly spoilt by his mother and, as the eldest son, benefited from the support of his family, receiving loans and gifts of money from his Aunt Charlotte until well into his twenties. His brother William, who became a clerk in the Excise Office in 1845, was also a frequent supplier of 'tin'.

Rossetti enrolled as a student in the Antique School of the Royal Academy in December 1845. He was 18 years old, 5 ft 7½ in tall, with long hair and a slim figure (see Plate 1), which, owing to his lifelong indolence, he was not to retain. He rapidly gained a reputation among his fellow students as a poet and Bohemian, and, being charismatic, enthusiastic and impetuous, he was a natural leader. His education was considerably above the average, he was well-read and a good linguist who had already translated the German epic, *Nibelungenlied*. Rossetti found the regime at the Antique School, like all regimes, unsympathetic. Training comprised drawing from casts and engravings of classical sculpture, in outline and with shading, until the student was considered sufficiently dextrous to move on to the Life School where live models were employed. Furthermore, he was unsure whether his future lay in painting or in literature and it may have been this doubt that led him, in 1847, to write to William Bell Scott (1811–90), another painter-poet, then Head of the Government School of Design in Newcastle, to praise his poetry and enclose some of his own verse for comment. In June he sent verses to the eminent critic Leigh Hunt and in October, describing himself as 'an enthusiastic admirer', he wrote to the poet Robert Browning. However, although two of these letters were to result in friendships none had

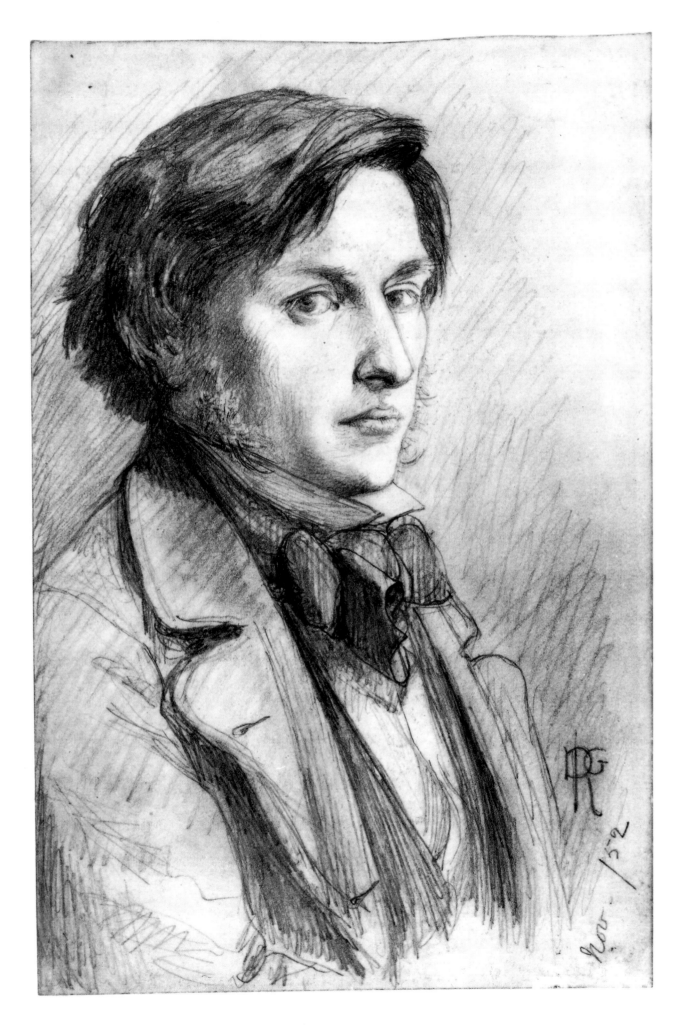

the profound effect produced by the letter he sent, on 24 March 1848, to the painter Ford Madox Brown (1821–93) (Fig. 2), asking for private lessons. Brown's reaction is well known; a proud and embittered widower of 27, unaccustomed to friendly praise, he treated the letter with suspicion and went round in person to Charlotte Street determined to discover its meaning. Assured by Rossetti of his seriousness, Brown accepted him and refused a fee. The first lesson took place on 4 May and Rossetti found it no more congenial than his earlier studies. By July, when Brown went to Paris, formal lessons were over but a lasting friendship had begun.

At the Academy exhibition in May, Rossetti had seen William Holman Hunt's *Porphyro and Madeline Leaving the Castle* (Guildhall Art Gallery, Corporation of London), a subject from 'The Eve of St Agnes' by John Keats, and, recognizing a fellow enthusiast for the poet, he had introduced himself with extravagant praise for the picture. Hunt, flattered by Rossetti's attention, agreed to help him with his work and in August 1848 they took a studio together in Cleveland Street. Hunt's greatest friend at the Academy Schools was John Everett Millais, who had entered the Antique School at 11 and was now, aged 19, a student in the Life School. The two young men, Hunt (Fig. 3) earnest and painstaking, Millais (Fig. 4) phenomenally talented, were seldom apart, and in fervid discussions they anatomized the failings of the Academy and the sorry state of British art. Hunt, who was drawn to naturalism, felt encouraged and vindicated when reading the second volume of *Modern Painters*, by the critic and philosopher John Ruskin (1819–1900) (Fig. 5), in which he found the oracular injunction, 'Go to Nature in all singleness of heart, selecting nothing, rejecting nothing.' Rossetti, who had no love for academies, was easily influenced by Hunt's rhetoric and adopted his theories with enthusiasm and incomprehension. Both Hunt and Millais joined the Cyclographic Society founded by Rossetti and his friend Walter Howell Deverell (1827–54) in 1847, the members of which circulated drawings for constructive criticism by their fellows. In September Rossetti attempted to form a literary society with Hunt, William Michael and James Collinson (1825–81), a painter and, at that time, Christina Rossetti's fiancé. The attempt came to nothing but proved to be the stillborn harbinger of a new society which, although short-lived, was to be associated with them not only in their lifetimes but to the present day, the Pre-Raphaelite Brotherhood.

Late in September 1848 Rossetti and Hunt went to the Gower Street house of Millais's parents where they studied Carlo Lasinio's engravings of frescos in the Campo Santo in Pisa by the Florentine artist Benozzo Gozzoli (c1421–97). These, according to Hunt, were innocent and naïve but 'full of incident derived from attentive observation of inexhaustible Nature'. They were, he claimed, 'Chaucerian', and, although deficient in perspective, they were in marked contrast to the derivative and formulaic work practised and preached by Royal Academicians. Inspired by the engravings the three determined to form an anti-Academic society. Within days Rossetti had recruited William, Collinson and Thomas Woolner (1825–92), a sculptor, into the conspiracy, and Hunt, probably alarmed by Rossetti's hijacking of what was almost certainly his idea, invited his pupil F G Stephens, to join. There were no more admissions.

The extent to which the group shared any common purpose or philosophy is debatable but, ostensibly, their avowed aim was to break free from the shackles of the Royal Academy (in whose Schools all but William had trained) and what they saw as its sterile and synthetic practices, and seek inspiration not from precept but from nature. Believing, with some justification, that the tradition they opposed had descended from the followers of Raphael (1483–1520), particularly the much admired Bolognese School founded by the Carracci family in 1585, they adopted the name Pre-Raphaelite to signify their admiration for the fifteenth-century Italian and Flemish artists who preceded the High Renaissance. Furthermore, they swore to avoid the sentimental and vapid subjects which predominated in the Annual Exhibition and to devote themselves to morally pure and emotionally truthful themes. At Rossetti's suggestion the Pre-Raphaelites added the word 'Brotherhood' to their title, signifying fellowship and a shared and serious purpose. Throughout the winter of 1848 and the whole of 1849 the Brothers held regular meetings which William, as Secretary, dutifully minuted. The practising members each resolved to paint a work in the new manner for the 1849 Exhibition which would bear the mystifying initials P R B; in the meantime the society was to be a strict and inviolable secret.

The artistic agenda was entirely Hunt's and Millais's, and it was almost certainly the latter who influenced the others to adopt the idiosyncratic style of drawing which prevailed among the Brothers in the early 1850s, characterized by angularity, elongation and attention to detail, and executed in a fine line with close hatching. His drawing, *Lovers by a Rose Bush* (Fig. 6), which he gave to Rossetti in 1848, is probably the earliest drawing in the new style and is one of consummate skill and elegance. Rossetti took *The Girlhood of Mary Virgin* (Plate 2) as the subject of his first P R B painting, the very title, with its unusual juxtaposition of her name, suggesting archaism and signifying something new and strange. He had begun it in the summer of 1848, before the foundation of the Brotherhood, supervised and assisted by both Hunt and Brown. In common with his fellow Brothers he used family and friends as models, Christina sat for the Virgin, his mother for St Anne and 'Old Williams', the Rossettis' odd-job man, for St Joachim. The painting is literally packed with Christian symbolism and contains, in an unsophisticated form, almost all the elements that characterize his later work: the symbolism of flowers, strange archaic furniture, inscriptions on the picture surface and the use of architectural devices to restrict the amount of visible landscape, a practice used by Hunt in his *A Converted British Family Sheltering a Christian Priest from the Persecution of the Druids* of 1850 (Ashmolean Museum, Oxford, see Fig. 7). The meaning of the painting was made doubly

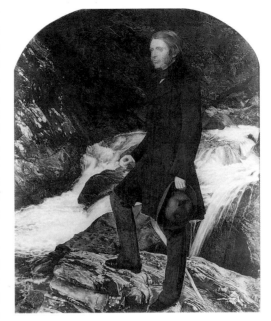

Fig. 5
JOHN EVERETT MILLAIS
Portrait of John Ruskin
1854. Oil on canvas, 71.8 x 61 cm.
Private collection

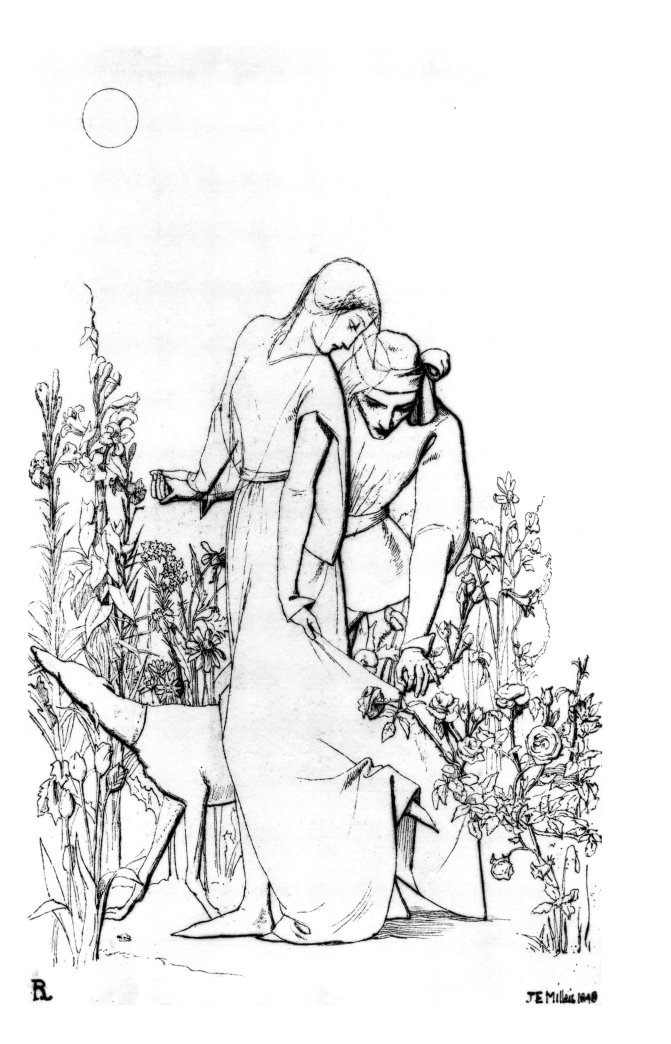

clear by the addition of two sonnets, a practice that was to be a lifelong habit. Despite the Brothers' sworn intention to show their revolutionary works at the Academy, Rossetti displayed *The Girlhood of Mary Virgin* in the spring of 1849, at the recently founded Free Exhibition, established by the Society of Artists in response to the perceived inadequacies of the Academy Hanging Committee. The Free did not impose a selection procedure and Rossetti's decision to show there is the first sign of the fear of rejection and criticism which was later to obsess him. Surprisingly, given its idiosyncrasies, the picture was well received and, with the assistance of his Aunt Charlotte, Rossetti sold the painting for £80 to her employer, the Dowager Marchioness of Bath.

After his technical difficulties with the painting it was probably a relief for Rossetti to turn to drawing, taking as his subject *Dante Drawing an Angel on the First Anniversary of the Death of Beatrice* (Fig. 20), which he completed in 1849 and presented to Millais. It is not only Rossetti's finest drawing in the early Pre-Raphaelite style but it is also significant as the first visual manifestation of his lifelong interest in Dante Alighieri, particularly the *Vita nuova*, an autobiographical fragment which he had translated by November 1848. There is no doubt that from now on Rossetti identified with the Dante of the *Vita nuova*, which tells of his mystical platonic love for Beatrice Portinari who died on 9 June 1290, aged 26, and that the reconciliation of 'Soul's Love', by which he meant platonic love, and earthly passion frequently preoccupied him after 1860. As if to signal his new allegiance he now changed the order of his given names, placing Dante before Gabriel and dropping Charles completely; to his family and friends he remained Gabriel but he was adamant about the order of his initials, rebuking his amiable Aunt Charlotte when she addressed a letter incorrectly.

On 27 September 1849, having sold *The Girlhood of Mary Virgin*, Rossetti and Hunt set off for Paris and the Low Countries and, in letters home, he revealed his taste in painting and architecture. He found Notre Dame 'inconceivably stunning', and admired the Gothic architecture of Bruges. Among others he particularly admired the fifteenth- and sixteenth-century artists Leonardo, Raphael, Hans Memlinc, Jan van Eyck and Giorgione, and his contemporaries Paul Delaroche, Hyppolite Flandrin, Jean-Auguste-Dominique Ingres and Ary Scheffer. He reserved his dislike for Eugène Delacroix, 'an absolute beast' – an opinion he was later to reverse – and Peter Paul Rubens, for whom he retained a lifelong aversion. Long narrative poems about his travels were sent to William as were serious sonnets inspired by art and an extremely coarse one provoked by the Can-Can. In November he returned to London.

Just before Rossetti and Hunt left for France the Brothers had held a meeting to discuss their forthcoming monthly magazine, a project dear to Rossetti's heart which he had first mooted in July. The periodical was to promote Pre-Raphaelite principles through criticism and example, and each issue was to contain an etching. All the Brothers were to be the proprietors, sharing profit or loss, and William was appointed Editor. Rossetti's original title was 'Thoughts towards Nature' but this was changed to *The Germ* in December 1849, from a list of 65 alternatives supplied by Brown's friend, the painter William Cave Thomas (active 1838–84). Friends and acquaintances including Brown, Deverell, Christina Rossetti and the poet Coventry Patmore were called upon for contributions. *The Germ* was printed by George Tupper, the father of John Lucas Tupper a former Academy student. The first issue appeared on 1 January 1850 and sold only 200 of the

Fig. 6
JOHN EVERETT MILLAIS
Lovers by a Rose Bush
1848. Pen and ink on paper, 18 x 11 cm.
Birmingham Museum and Art Gallery

700 printed, the second, in a smaller run of 500, sold even fewer and the Brothers, alarmed by the financial losses, were only prevented from abandoning the project by the generosity of Tupper who offered to underwrite two further issues. The Tuppers' financial interest was reflected in a change of title, to *Art and Poetry*, and their dominant authorship of issues three and four, in which undergraduate humour overwhelmed the serious literary contributions of the P R B. *The Germ*, although a financial disaster, saw the first publication of verse by Christina Rossetti, albeit anonymously, and Gabriel's 'The Blessed Damozel'. It also launched the critical careers of William and F G Stephens, who were shortly to become the art critics for the *Spectator* and *Athenaeum* respectively.

In January Rossetti began work on *Ecce Ancilla Domini!* (Plate 3), intended for the Academy Exhibition of 1850. 'The Annunciation', as he retitled the picture to avoid suspicions of Popery, bears a clear relationship to *The Girlhood of Mary Virgin* (Plate 2), containing the same embroidery stand, now folded, which bears the finished embroidery on which the Virgin was working in the earlier painting. As usual Rossetti had difficulties with the picture, particularly the perspective, and received help from Millais and Stephens. He was to work on it long after its exhibition, exhorting Brown to help him with 'the Blessed white eyesore' as late as January 1853. Once again Christina sat for the Virgin and William for the Angel, the flames at the latter's feet were painted, according to strict P R B principles, from life. As in 1849, despite a pact with Hunt and Millais, Rossetti drew back from facing the Hanging Committee and exhibited in April with the

National Institution. His friends were angry suspecting that his true motive was to show his work before the Academy Exhibition opened and thus steal the limelight from their own works, Hunt's *A Converted British Family Sheltering a Christian Priest from the Persecution of the Druids* and Millais's *Christ in the House of his Father* (Tate Gallery, London).

They had other reasons for being displeased with Rossetti for it was almost certainly he, loquacious and affable as ever, who had revealed the existence of the Brotherhood and what the letters P R B stood for. By the spring of 1850 the movement was common knowledge in London literary and artistic circles, and by no means approved of. The very secrecy of the Brotherhood was seen as subversive, the youthfulness of its members made their presumption impudent, their chosen name smacked of Catholicism and the inscription P R B on their paintings seemed to imply that they had awarded themselves an accolade, rather than vie with their fellows for the coveted initials R A. When they exhibited in 1850 their critics were ready and waiting. Hunt and Millais, particularly the latter whose painting was described by the *Athenaeum* as a 'pictorial blasphemy', were subjected to vicious criticism when the exhibition opened. Charles Dickens wrote a vitriolic attack on *Christ in the House of his Father*, in *Household Words*, which deeply upset Millais's mother, who, according to Hunt, blamed Rossetti for the critical onslaught. Rossetti, shaken by attacks on his own painting, swore never to exhibit publicly again. Fortunately for Millais his painting was already sold and he also found a purchaser for Hunt's work. The Pre-Raphaelites were assiduous in advancing the careers of their friends.

Although Rossetti's indiscretion may have provoked the critics he was totally innocent of any part in the development of the style which they attacked. Hunt and Millais between them were responsible for the technical advances which exasperated the artistic establishment, in particular the use of a white ground to enhance the brilliance of the colour and the disquieting luminosity achieved by ignoring the accepted conventions of landscape painting. In October, forgiven, Rossetti joined Hunt and Stephens in Sevenoaks to paint landscape backgrounds in Knole Park. While the painstaking Hunt worked on *Valentine Rescuing Sylvia* (Birmingham Museum and Art Gallery), the facetious Rossetti wrote to John Tupper on 25 October, 'I myself had to paint under the canopy of Heaven, without a hat, and with my umbrella tied over my head to my buttonhole – a position which, will you oblige me by remembering, I expressly desired should be selected for my statue (NB Trousers turned up).' An attempt to resolve the tensions in the Brotherhood was made at a meeting in January 1851, when it was agreed that fines would be levied for non-attendance and that each member should write a personal manifesto; William recorded that he was the only Brother to do so and, unfortunately, mislaid it.

In 1851 Rossetti, as he had sworn, did not exhibit, but the criticism continued and this time included attacks on Brown, whose *Chaucer* (Tate Gallery, London) was considered to show Pre-Raphaelite tendencies. Criticism at both the 1850 and 1851 exhibitions was largely the work of writers and journalists rather than artists, many of whom were supportive. The genre painter Augustus Egg (1816–63) commissioned Hunt to paint *Claudio and Isabella* (Walker Art Gallery, Liverpool), and their work was admired by the historical painters Charles West Cope (1811–90) and William Dyce (1806–64). It was the latter who came to the aid of the beleaguered Brothers in 1851 when he advised his friend, John Ruskin, to visit the Academy to inspect Millais's *Return of the Dove to the Ark* (Ashmolean Museum, Oxford).

Fig. 7
WILLIAM HOLMAN HUNT
Study for A Converted British Family Sheltering a Christian Priest from the Persecution of the Druids
1849. Pen and ink on paper, 22.8 x 29.8 cm.
Johannesburg Art Gallery

The 32-year-old Ruskin was best known as the connoisseur and champion of J M W Turner (1775–1851) and as the author of *The Seven Lamps of Architecture* of 1849, which extolled the virtues of the Gothic over the Classical style. He was also a formidable and respected critic. Admiring Millais's painting, he wrote two letters to *The Times*, on 13 and 30 May 1851, in which he dissected the attacks on perspective, drawing, colour and light and found them indefensible, detecting prejudice rather than reason. Ruskin's future relationships with the Brothers were to prove both personally and artistically complex but there can be no doubt that his intervention in 1851 made them largely impervious to further attacks.

Rossetti, who had been living with his family, left home in November 1852 to move into rooms overlooking the River Thames at 14 Chatham Place, Blackfriars. The landscape painter George Price Boyce (1826–97), who first visited on 30 December, reported that he had hung the rooms with lithographs by Gavarni (1804–66) and also had 'a good and most striking mask of Dante taken from a cast of his head in death'. The move may have been partly occasioned by his relationship with Elizabeth Siddal with whom he was in love. Rossetti was introduced to her in September 1850 by Deverell who, supposedly, had first seen her in a milliner's shop, working as an assistant. She was then 21 years old and living in Bermondsey in the house of her father, an ironmonger. She was not conventionally pretty but had golden red hair which Rossetti particularly admired (see Plate 4). Initially she modelled for all the Brothers, most famously for Millais's *Ophelia* (Tate Gallery, London), but after 1852 when she became engaged to Rossetti, she sat solely for him. To some extent Rossetti identified himself and Lizzie with Dante and Beatrice. In his unfinished prose tale, 'St Agnes of Intercession', begun in 1850, the year they first met, the hero, painting the portrait of his dying fiancée as St Agnes, realizes that they are the doubles of a fifteenth-century Florentine painter and his dying lover: the theme of the doppelgänger, one's spirit-self, a meeting with which presages one's death, fascinated Gabriel during this period. Lizzie sat for Beatrice in the 1851 watercolour, *Beatrice Meeting Dante at a Marriage Feast, Denies him her Salutation* (Plate 8) and *Dante Painting a Portrait of Beatrice*, 1853 (location unknown), among others, and was finally immortalized after her death in *Beata Beatrix* (Plate 26). However too much emphasis should not be placed on the evidence of the paintings alone since, as his principal model during the 1850s, she sat for the majority of his pictures painted in this period.

In April 1853 the Brothers met to draw portraits of each other to send to Woolner who had emigrated to Australia in July 1852. They had held no meetings the previous year and this was to be their last; the Pre-Raphaelite Brotherhood was effectively over. Collinson had resigned in May 1850 and also broken off his engagement to Christina by returning to the Roman Catholic Church. William saw the decline, probably correctly, as the result of individual success, which was certainly true of Millais whose *Huguenot* (Private collection), shown at the Academy in 1852, had been a popular success. In November he became an Associate of the once despised Academy and Gabriel, echoing Tennyson's 'Morte d'Arthur', wrote to Christina, 'So now the whole Round Table is dissolved.'

Hunt sailed for the Holy Land on 14 January 1854, determined to devote his talents to the cause of Christianity. He was not to return until February 1856 and his companion for much of his stay, Thomas Seddon, was to die in Cairo in November of that year. 1854 was momentous for Rossetti too, for on 14 April he first met Ruskin who had been shown his work by Francis MacCracken, an early patron and

Fig. 8
WILLIAM HOLMAN
HUNT
Portrait of Dante
Gabriel Rossetti
1853. Oil on canvas,
29.2 x 21.5 cm.
Birmingham Museum and
Art Gallery

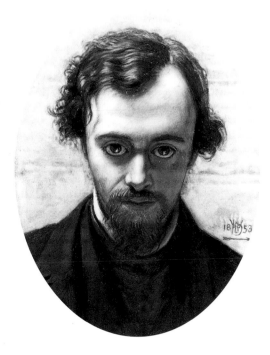

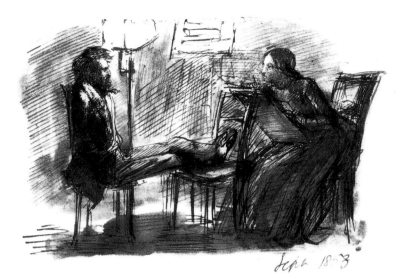

Fig. 9
Rossetti Sitting to
Elizabeth Siddal
1853. Pen and ink on
paper, 11 x 16.5 cm.
Birmingham Museum and
Art Gallery

Fig. 10
ELIZABETH SIDDAL
Lovers Listening to
Music
1854. Pencil, pen and ink
on paper, 24 x 30 cm.
Ashmolean Museum,
Oxford

the owner of *Ecce Ancilla Domini!* (Plate 3). From the first Rossetti had a somewhat ambivalent attitude to Ruskin, writing to Brown after the first meeting, 'In person he is an absolute Guy', but adding later in the letter, 'he seems in a mood to make my fortune'. At the time of their meeting Ruskin was particularly emotionally vulnerable, for his previous Pre-Raphaelite protégé, Millais, had fallen in love with Effie, Ruskin's wife, who was now in the process of divorcing him for the non-consummation of their seven-year-old marriage. Over the next two years he bought ten of Rossetti's drawings and watercolours and commissioned his only oil painting, *St Catherine* (Plate 13). He often paid more than the asking price, but he was a difficult patron, finding it impossible to restrain his pedagogical instincts. He frequently suggested subjects and criticized Rossetti's methods and technique, sending back *The Nativity* in June 1855 for the painter to 'take the pure green out of the face'.

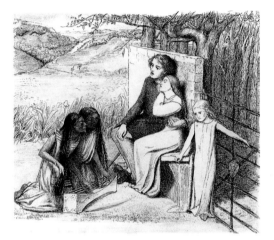

By 1854 Lizzie had become Rossetti's pupil as well as his muse and had produced a number of drawings in the angular Pre-Raphaelite style invented by Millais (Fig. 9). In March 1855 he showed her drawings to Ruskin who, Gabriel excitedly reported to Brown, bought all her work. In his enthusiasm Rossetti sold Ruskin *Lovers Listening to Music* (Fig. 10), which had already been purchased by his friend, the poet William Allingham. In April Ruskin went further by settling an annual sum of £150 on Lizzie in return for all her work. Perhaps to reduce the constant strain on Rossetti, he also took a close interest in her health, which was causing concern. In the summer Ruskin sent her to Oxford, for a consultation with Dr Acland, and, late in September, on Acland's advice, she was sent on a convalescent trip to France accompanied by Ruskin's kinswoman Mrs Kinkaid. 'He is the best friend I ever had', Gabriel wrote to his Aunt Charlotte, adding diplomatically, 'out of my own family'. In an attempt to repay some of Ruskin's kindness Rossetti had agreed at the beginning of the year to take a life class at the Working Men's College, recently established by the Revd F D Maurice, where Ruskin himself taught. It was here, in 1856, that Rossetti was to meet Edward Burne-Jones (1833–98).

When he was not absorbed by commissions from Ruskin and Lizzie's problematic health Rossetti was struggling with *Found* (Plate 6), his 'modern' subject, showing a fallen woman recognized by her former fiancé on his way to market. The 'modern' subject, far removed from the religious, romantic and poetic themes they had

Fig. 11
Maids of Elfen-mere
1854. Engraving.
Illustration to William
Allingham's 'Maids of
Elfen-mere' in *Day and
Night Songs* (London, 1854)

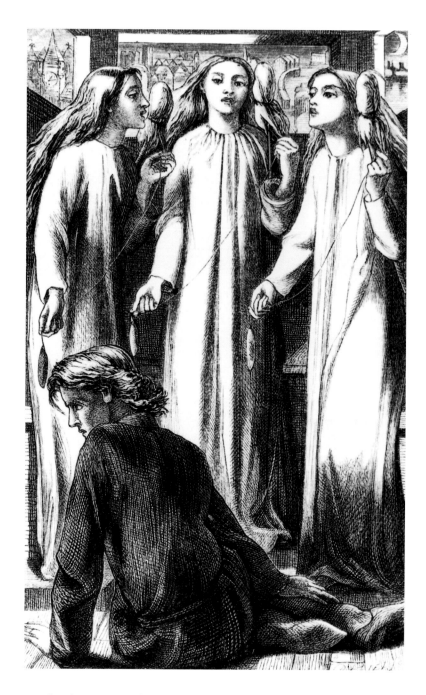

previously attempted, absorbed the Brothers and their circle in the first half of the 1850s. In these paintings, the most famous of which is Brown's *Work* (City Art Galleries, Manchester) begun in 1852, direct critical comments are made on contemporary society, a practice which, since William Hogarth (1697–1764), had been almost entirely the province of the caricaturist. *Found*, which was never completed, caused Rossetti great difficulties. The unfortunate picture was also one of the causes of Rossetti's estrangement from Hunt, who claimed without proof that Rossetti had stolen the idea from his own 'modern' painting, *The Awakening Conscience* (Tate Gallery, London), shown at the Academy in 1854.

Rossetti was introduced to Edward Burne-Jones, who had attended a class at the Working Men's College for the express purpose of meeting him, in January 1856. Burne-Jones and his friend William Morris (1834–96), undergraduates at Exeter College, Oxford, were enthusiastic followers of the Pre-Raphaelites, whose work they had seen in Oxford and Paris. They had read and admired *The Germ*, on which they based their own periodical, *The Oxford and Cambridge*

Magazine. In the first issue, which had just appeared, Burne-Jones wrote of Rossetti's illustration to William Allingham's 'Maids of Elfenmere' (Fig. 11), 'It is, I think, the most beautiful drawing for an illustration that I have ever seen.' Burne-Jones and Morris, originally destined for the Church, had been inspired by reading Ruskin, Charles Kingsley and Thomas Carlyle, to declare 'a crusade and Holy War against the age', and they resolved to become a painter and an architect respectively. It was this decision that led Burne-Jones to seek out Rossetti.

Morris and Burne-Jones were both enthusiastic medievalists, steeped in chivalry and Arthurian legend, and, by a happy coincidence, Rossetti too had recently turned his attention to Malory. He may have become interested in Arthurian themes through Tennyson, having recently been commissioned to provide four illustrations for Moxon's edition, *St Cecilia* (Fig. 12) and *King Arthur and the Weeping Queens* (Fig. 23). His first Arthurian painting, depicting an incident devised by Rossetti, was *Arthur's Tomb: The Last Meeting of Launcelot and Guinevere* (Plate 7), begun in 1854 and bought by Ruskin the following year. With one exception, a replica painted in 1864, *How Sir Galahad, Sir Bors and Sir Percival were Fed with the Sanc Grael; but Sir Percival's Sister Died by the Way* (Plate 25), Rossetti's Arthurian subjects are confined to the three-year period 1855–8, temporarily replacing Dante as a major source of inspiration, and it seems likely that his interest was sustained during this period by the enthusiasm of the younger men, Morris and Burne-Jones.

Morris, a wealthy man, also proved a useful patron buying six Rossetti watercolours, as well as *April Love* by Arthur Hughes (1830–1915) and Brown's *Hayfield* in 1856 (both in the Tate Gallery, London). The watercolours included *The Blue Closet* (Plate 10) and *The Tune of Seven Towers* (Plate 12), which, together with *The Wedding of St George and the Princess Sabra* (Plate 11) and *A Christmas Carol* (Plate 14), are among the finest and most individual of Rossetti's paintings, being intense, enigmatic and almost claustrophobic illustrations of a personal medieval world. Morris, who was already writing poetry, published several verses inspired by Rossetti's Arthurian watercolours in *The Defence of Guinevere* of 1858, which he dedicated to Gabriel.

The Arthurian period of Rossetti's career was to end with a spectacular, if ill-judged, experiment in public art. In July 1857 he was

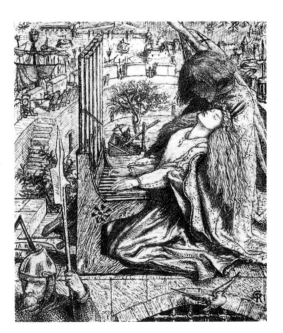

Fig. 12
St Cecilia
1856–7. Pen and ink
on paper, 9.6 x 8.2 cm.
Birmingham Museum
and Art Gallery

Fig. 13
Sir Launcelot's Vision
of the Sanc Grael
1857. Watercolour on
paper, 68 x 103.5 cm.
Ashmolean Museum,
Oxford

Fig. 14
Portrait of Jane
Burden, Aged 18
1858. Pen, ink, pencil and
wash with white highlights
on paper, 49.2 x 37.6 cm.
National Gallery of
Ireland, Dublin

invited by the Gothic Revival architect Benjamin Woodward to provide a mural for the new Science Museum at Oxford. He refused, but offered instead to decorate Woodward's extension to the Oxford Union building, only charging for expenses and materials; back in London, he assembled a team of painters including his disciples Morris and Burne-Jones. The murals, on subjects from the *Morte d'Arthur*, were to be painted on the spandrels below the roof, each of which was pierced by windows. The excursion was highly enjoyable but the outcome a disaster for, inexperienced in fresco, they painted in unsuitable materials on unsuitable surfaces and within months the work was deteriorating. Rossetti's subject, *Sir Launcelot's Vision of the Sanc Grael* (Fig. 13), remained unfinished. However, two events during the Oxford fiasco were to change the lives of Morris and Rossetti. The first was Morris's discovery of a natural gift for decorative pattern. The second was the chance meeting, in a theatre, with the 18-year-old Jane Burden (Fig. 14), an ostler's daughter, who was to marry Morris and love Rossetti; Morris's subject for his Oxford mural, *How Sir Palomydes Loved La Belle Isault with an Exceeding Great Love, but How she Loved not him but rather Sir Tristram* was to be sadly prophetic.

Throughout 1858 Rossetti was preoccupied with religious subjects, including the spectacular ink drawing of *Mary Magdalene at the Door of Simon the Pharisee* (Fig. 24), which Ruskin wished to exchange for his painting of *St Catherine* (Plate 13). His return to the religious subjects of his early paintings is explained by a commission to paint an altarpiece for Llandaff Cathedral, received from the architect John P Seddon, Thomas Seddon's brother, in 1856. He chose as his subject *The Seed of David* (Plate 15).

Morris married Jane Burden in 1859 and on their return from a honeymoon in Bruges and Paris they lived at the Red House, Bexleyheath, Kent, designed for Morris by his friend Philip Webb, whom he had met during his brief architectural training in the office of G E Street. Burne-Jones, his wife Georgiana and Rossetti soon became involved in furnishing and decorating the Red House in an appropriately medieval manner, Gabriel contributing *Dantis Amor* (Plate 19), which he painted on a cupboard door in 1860, the year in which he finally married Lizzie Siddal. The two had been estranged since July 1858 when she had gone to relations in Sheffield, he had stayed with her in Matlock in the winter of 1858–9 but seems to have seen nothing more of her until the spring of 1860, when he visited her in Hastings where she had gone for her health. Lizzie had undoubtedly been upset by Rossetti's casual infidelities, particularly that with

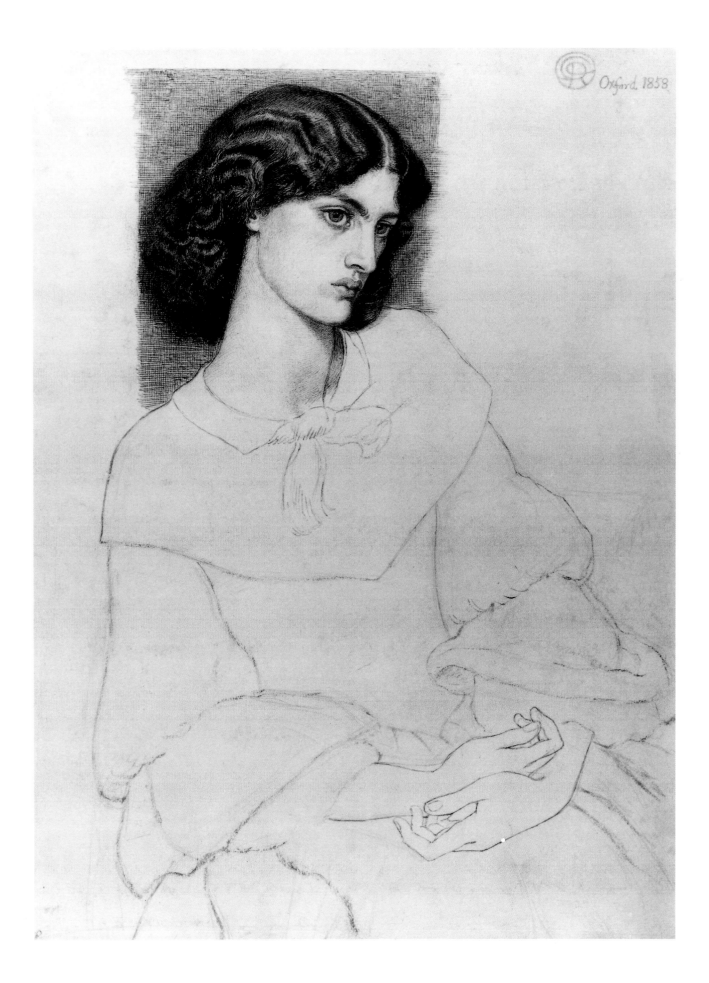

Oxford. 1858

Annie Miller, Hunt's model and highly unsuitable intended wife, which had taken place during Hunt's absence abroad, and there were certainly others. For his part Rossetti may have found Lizzie's seemingly constant illnesses too much to bear, but there were doubtless deeper reasons, perhaps not unconnected with his confusion over 'Soul's Love' and 'Earthly Love', which made him reluctant to marry her. They wed in Hastings on 23 May when Rossetti was convinced that she was dying.

In November 1859 Rossetti wrote to William Bell Scott, 'I have painted a half figure in oil, in doing which I have made an effort to avoid what I know to be a besetting sin of mine, and indeed rather common to P R painting – that of stippling on the flesh.' This small picture, *Bocca Baciata* (Plate 18), was a turning point in Rossetti's career, and he recognized it as such. It was painted for his fellow painter George Price Boyce (1826–97), from Fanny Cornforth (Fig. 27), a model he had met in Cremorne Gardens in 1856. According to William she was 'a pre-eminently fine woman, with regular and sweet features, and a mass of the most lovely blonde hair', she was also good-natured and sensual and, despite two marriages, was to become Rossetti's mistress, housekeeper and confidante for the rest of his life. *Bocca Baciata*, 'The Mouth That Has Been Kissed', is not only more freely painted than any of his previous works, but establishes a format in which the sitter, wearing exotic jewellery, is contained by a foreground shelf or balcony against a richly patterned, usually floral, background, which he used with only slight variations in all his subsequent portraits. He was not alone in recognizing the picture as a new departure. The pious Hunt, who had not forgiven Rossetti for his liaison with Annie Miller, detected indecency: 'Still more remarkable for gross sensuality of a revolting kind peculiar to foreign prints', he wrote to his patron William Combe, 'I see that Rossetti is advocating as a principle the mere gratification of the eye ... the animal passions to be the aim of art.' Ruskin, too, cannot have approved of Rossetti's change of direction. In 1861 he underwrote the publication of *The Early Italian Poets*, which included Dante's *Vita nuova*, but the two men were no longer close and by 1867 he had grown to dislike Rossetti's work, writing to him of the flowers in *Venus Verticordia* (Plate 27), 'They were wonderful to me, in their realism: awful – I can use no other word – in their coarseness: showing enormous power, showing certain

Fig. 15
CHARLES LUTWIDGE DODGSON (LEWIS CARROLL)
The Rossetti Family at Cheyne Walk (from left to right: D G Rossetti, Christina Rossetti, Frances Rossetti, William Michael Rossetti)
1863. Photograph.
National Portrait Gallery, London

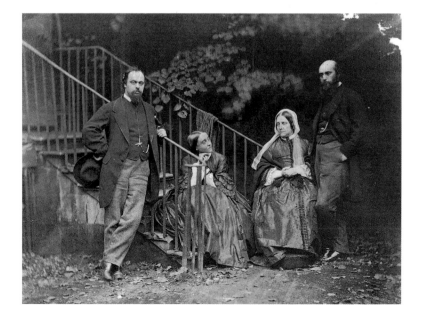

conditions of non-sentiment which underlie all you are doing – now.' Their last meeting took place the following year.

The Firm of Morris, Marshall, Faulkner and Company was founded in April 1861, with seven partners including Burne-Jones, Brown and Rossetti, as an art manufacturing business determined to improve the standard of decorative art. Initially they relied heavily on commissions for stained glass. Rossetti provided about 30 stained-glass designs, including *The Sermon on the Mount* (Plate 21), before he ceased in 1864, possibly in retaliation to a resolution of the partners' meeting in April 1863 which obliged him 'to alter the costume of his Mary Magdalene for Bradford East Window on account of its inappropriateness for its destination'. He also designed a chair for the Firm and an extraordinary couch for the 1862 Exhibition, which somehow managed to look both Japanese and Egyptian simultaneously.

Lizzie's mental and physical health suffered further in May 1861 when she gave birth to a stillborn child, and she was now addicted to sleeping draughts. On the evening of 10 February 1862, having dined with the poet Algernon Charles Swinburne, the Rossettis returned to Chatham Place together before Rossetti went out alone for reasons which remain unclear. On his return in the early morning he discovered that she had taken an overdose of laudanum. Although a verdict of accidental death was recorded at the inquest on 12 February there is little doubt that she had taken her own life, Brown having destroyed a note, which she had pinned to her nightdress, to conceal the suicide. She was buried with a notebook of Rossetti's manuscript poems placed beside her hair in the family grave at Highgate, where his father, who had died in 1854, was interred.

Rossetti stayed briefly with his mother and then with Brown before taking rooms in Lincoln's Inn Fields. In October he moved to Tudor House, 16 Cheyne Walk, Chelsea, together with William who kept a room there until his marriage to Brown's daughter Lucy in 1874, the poet and novelist George Meredith who stayed for a year, and Swinburne who was finally asked to leave in 1866 when his excesses proved too much for even the unshockable Rossetti to accept. In addition to the tenants the household included a succession of servants, his unpaid assistant Walter Knewstub, replaced in 1867 by Treffry Dunn, and Fanny Cornforth who, for the sake of propriety, lived nearby in lodgings rented by Rossetti. For the next five years he was prosperous and seemingly happy, holding frequent parties and entertaining, among others, Frederic Leighton (1830–96), James McNeill Whistler (1834–1903), with whom he competed in collecting Oriental china, Lawrence Alma-Tadema (1836–1912) and Alphonse Legros (1837–1911), in addition to his usual circle (Fig. 15). He became notorious for his menagerie which, at one time or another, contained two kangaroos, a raccoon and an armadillo, salamanders, deer, buffalo, owls and peacocks and, in 1869, his beloved wombat (Fig. 16).

In his studio, furnished with antique chests that housed his large collections of props for use in his paintings, he would entertain his clients, who, as he never exhibited, came to him by recommendation. Occasionally, when pressed for 'tin', he would sell directly to a dealer who kept any profit from the resale. Most of his patrons were northern businessmen, made rich by the Industrial Revolution, and mostly he treated them abominably. His usual practice was to demand a large down payment in advance and the balance on completion which, since he was famously unable to complete pictures on time, sometimes found him owing considerable amounts of money to the estates of purchasers who had died while waiting for their paintings, 680 guineas in the case of Thomas Plint in 1861.

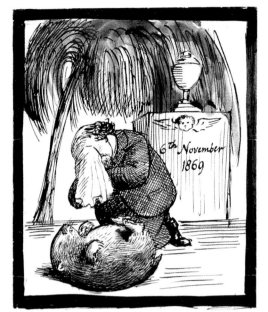

Fig. 16
Death of a Wombat
1869. Pen and ink on paper, 18 x 11 cm.
British Museum, London

Throughout 1862 he was engaged in a long correspondence with Anne Gilchrist, widow of the writer Alexander Gilchrist, who he was assisting, with Swinburne, to complete her husband's *Life of William Blake*, and designing stained-glass windows for the Firm. Two years later he resumed work on a subject started 'many years before', *Beata Beatrix* (Plate 26), the most haunting and haunted of his pictures, which he painted from studies of Lizzie made before her death, regarding it as a memorial to her. In November he visited Paris with Fanny, bearing an introduction to Henri Fantin-Latour (1836–1904) from Whistler. Through Fantin-Latour he met both Édouard Manet (1832–83) and Gustave Courbet (1819–77) and visited their studios where he was unimpressed by their work, describing the former's paintings as 'mere scrawls' and the latter's as 'not much better'.

Morris and Jane left the Red House and returned to London in 1865, living with their two small daughters Jenny and May above the Firm's premises in Queen Square, Bloomsbury. Their new proximity led to regular meetings and in July Rossetti persuaded Jane to pose for a series of photographs in the garden at Cheyne Walk (Fig. 36). A new model, Alexa Wilding, began to replace Fanny as his principal model, much to the latter's jealousy, sitting for *Regina Cordium* (Plate 31) and the Titian-esque *Monna Vanna* (Plate 30), both of which he completed in 1866. Miss Wilding continued to sit for Rossetti until 1879 and was paid a retainer from 1872. Described by Gabriel as 'Quite ladylike, only not gifted or amusing', her rather dull respectability won the approval of his mother, whereas the vulgar Fanny was never introduced to her.

In the late 1860s Rossetti began to exhibit symptoms which, in retrospect, can be seen as heralding the complete change in his character which was to emerge in the 1870s. In 1867 he became concerned about his eyesight but was assured by his physicians that there was nothing physically wrong. The trouble recurred in the following autumn and Rossetti went to recuperate at Penkill Castle, Ayrshire, the home of Bell Scott's patron and companion Alice Boyd. According to Bell Scott's somewhat unreliable memoirs, he considered Rossetti's illness to be psychosomatic, 'caused by an uncontrollable desire for the possession of' Jane Morris. Jane had sat for her portrait in March and it had been completed by the beginning of April and celebrated by a party at Cheyne Walk (Fig. 38). At the top of the canvas he had inscribed, in Latin, 'Jane Morris, AD 1868, Painted by D G Rossetti. Famed for her poet husband and surpassingly famous for her beauty, now let her gain everlasting fame by my painting'; discretion was not his forte.

The affair between Rossetti and Jane Morris was to continue until 1874 and their friendship until his death, it almost certainly contributed to the ill health of each of them and was probably a major cause of his subsequent breakdown. For the moment, in 1868, his passionate obsession was a spur to creativity and in 1869 while painting Jane as *La Pia de' Tolomei* (Plate 34), a Dante-esque subject of a wife condemned to die through her husband's indifference, he began to write verse again. In June it was Jane who was the invalid and Morris, who was completing his epic poem 'The Earthly Paradise', took her to Bad Ems, in Germany, to try a water cure. Rossetti, seemingly indifferent to Morris's feelings, sent her openly loving letters and caricatures including *The M's at Ems* (Fig. 37), with its clear implication that Morris was a boring and inconsiderate husband. His revived interest in writing, directly inspired by Jane, was the principal, although obfuscated, reason for the notorious disinterment of Lizzie Siddal's coffin to retrieve his manuscript verse which took place on 10

October 1869 when he was again staying at Penkill. Rossetti's motives in recovering the volume are not straightforward and he may have intended, consciously or not, to provide a smoke-screen which would allow him to publish the love sonnets to Jane while suggesting that they were addressed to his wife and written during her lifetime.

In the spring of 1870 Rossetti and Jane stayed at Scalands, the country home of his old friend Barbara Bodichon. On 25 April his *Poems* were published to pre-arranged critical acclaim, for Rossetti had ensured that they would be reviewed by Swinburne, Thomas Hake, a recent friend, and the much ill-used Morris. The latter, frantic and worried about the increasingly scandalous behaviour of Jane and Gabriel, and fearing it would become public, found a partial solution to the problem by taking a lease, with Rossetti, of Kelmscott Manor, near Lechlade in Gloucestershire, from May 1871. Having done so, finding the situation unbearable, he left for Iceland on 6 July and did not return until 20 September. Ten days after his departure Rossetti joined Jane and the children at Kelmscott.

The summer of 1871 was idyllic for Rossetti; Kelmscott, he wrote to his fellow painter Frederick Shields (1833–1911), 'is a perfect Paradise'. His eyesight improved immediately, he and Jane furnished the house and in the evenings they read Shakespeare and Plutarch together. Rossetti wrote nine sonnets and painted *Water Willow* (Plate 38), for which Jane posed by the River Thames in front of the Elizabethan manor. In October, shortly after his return to London, *The Contemporary Review* published an attack on his *Poems* by 'Thomas Maitland', under the title 'The Fleshly School of Poetry', which attacked both his verse and his paintings and, by implication, his character. Rossetti seemed unconcerned by the piece and much excitement was had in discovering the true author, Robert Buchanan, a minor poet, engaged in a personal vendetta against the Rossetti brothers. Gabriel responded to the article in 'The Stealthy School of Criticism', published in the *Athenaeum* in December. Skirmishes continued into 1872 but according to William's diary entry of 15 May, 'he seems sufficiently untroubled by it'; however, on 8 June he attempted suicide. Rossetti had been taken ill at Cheyne Walk on 2 June suffering from delusions, he was attended by his friend Hake, a physician, who, on 7 June, took him to his own house in Roehampton. During the night Rossetti took an overdose of laudanum but survived and by the 20 June, accompanied by Hake and Brown, he was en route to Scotland to recuperate. He remained there until the end of September, ill both mentally and physically, with a testicular tumour, 'a useful reality among his fancies', according to Hake. He suffered from paranoia and a complete lack of nerve which required him to be accompanied at all times, initially by Hake and Brown and later by Bell Scott and Hake's son George. He also complained of insomnia and was taking large draughts of chloral and quantities of whisky to a degree that caused concern. The belief that Buchanan's article was the major cause of Rossetti's breakdown, fostered by William after Gabriel's death, was a convenient explanation which allowed the real reason, his relationship with Jane Morris, to remain hidden from the public until well into the twentieth century.

Accompanied by George Hake, on 23 September he left Scotland for Kelmscott, where he was nursed by Jane. Morris deliberately kept away, explaining to a friend, 'it really is a farce our meeting when we can help it'. In December Jane went to London leaving Gabriel at Kelmscott until the summer of 1874. The affair was probably over and Rossetti a changed man; for the rest of his life he was subject to deep depressions, abrupt changes of mood and physical ailments. Once so

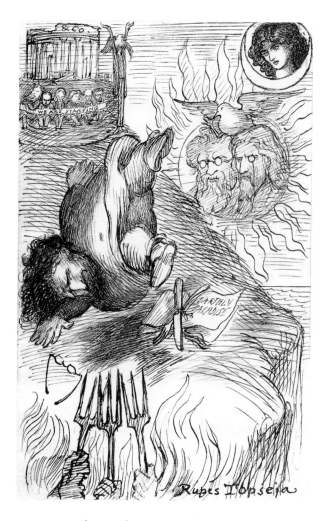

extrovert and gregarious he now became reclusive, hating society yet fearing loneliness. His illness did not affect his need and ability to work, Alexa Wilding came down to pose for *La Ghirlandata* (Plate 41), and he completed *Proserpine* (Plate 42), a subject he was to paint eight times, from sketches he had made of Jane in 1871. His frequent visitors included Brown, who recalled his daily walk taken alone at seven in the evening, 'straight as a crow flies ... and then home again, at a rapid pace as though it were a penance'.

In April 1874 Morris, who resented Rossetti's sole occupation of Kelmscott Manor, relinquished the lease, only to take it up again when Rossetti had given up his own share of the house. Having severed Rossetti's links with Kelmscott, Morris proceeded, in August, to dissolve the Firm and take sole control, not, it should be stressed, for personal but for commercial reasons. Rossetti, encouraged by Brown who was extremely upset, made half-hearted objections through his solicitor, Theodore Watts, but when the formal dissolution came on 23 October he insisted that his compensation of £1,000 be invested in a trust for Jane (see Fig. 17).

Rossetti spent the autumn of 1875 and the spring of 1876 in Bognor where Jane sat to him for *Astarte Syriaca* (Plate 46), a highly mannered and personal work of great intensity; there, he worked on *The Blessed Damozel* (Plate 45) and *A Sea-spell* (Fogg Museum of Art, Harvard University, Cambridge, MA), for which Alexa Wilding posed. In April he thought again of suicide, writing to George Hake:

> If I die suddenly at any moment ... let me not on any account be buried at Highgate, but my remains be burnt as I say. All letters from [Jane] to be burnt. My brother should, if possible, cause information to reach the writer of the letters that they had been burnt.

In April 1877 Rossetti was anxious about Jane's health, which was probably worsened by the discovery that her elder daughter, Jenny, suffered from epilepsy. By August he too was ill, suffering from a further tumour or hydrocele and on the 17th he went to convalesce at Hunter's Forestall, near Herne Bay, Kent, accompanied by Brown, who, having failed to wean Rossetti from his dependence on alcohol and drugs, departed in anger and frustration in September, causing a two-year break in their friendship. Shingles in his hands made it virtually impossible for him to work, and domestic difficulties with Fanny and financial problems added to his worries. Anxious not to be seen as an invalid for professional reasons, he wrote to *The Times* to refute their suggestion that he had refused to exhibit at the newly founded Grosvenor Gallery because of poor health. The reason, he wrote, was 'that lifelong feeling of dissatisfaction which I have experienced from the disparity of aim and attainment in what I have all my life produced as best I could'. In the autumn he returned to London and in November Jane departed for a prolonged stay in Italy.

Rossetti's financial problems were solved in December by the sale of three paintings for 1,500 guineas and, putting aside his own problems, he busied himself on behalf of the painter James Smetham (1821–89), whose religious mania had caused him to be placed in an asylum, by promoting the sale of his work. In May 1878 Jane, who had collapsed in Venice on the 2nd, returned from Italy accompanied by Morris and moved into a house on the River Thames at Hammersmith, which he promptly renamed Kelmscott House. In July she began sitting to Rossetti for *La Donna della Finestra* (Plate 47), his last subject from Dante. His final painting of her, *The Day Dream* (Plate 48), was painted for Constantine Ionides during the following year, from a favourite drawing that Rossetti kept on his mantelpiece.

By 1880 Rossetti was a virtual recluse, as Burne-Jones explained to a mutual friend, 'It's nine years since he came to The Grange – now he goes nowhere and will see scarcely anyone.' He refused all Jane's invitations to visit her in Hammersmith, although the two corresponded regularly and, in Rossetti's case, intensely and movingly. In the spring of 1881 he decided to republish his poems in two volumes, incorporating those that he had written since 1870. Jane, anxious both for herself and Rossetti, seems to have expressed some reservations to which he reacted angrily, hurt by her imputation of insensitivity, writing, in August: 'Every new piece that is not quite colourless will be withdrawn and the book postponed.' *Poems* and *Ballads and Sonnets* were published in the autumn; Jane's fears proved groundless, Gabriel and William had assiduously removed all clues to her identity.

In September, on the advice of his doctor, Rossetti travelled to Keswick in the Lake District with Fanny and a new companion, Hall Caine, who had supplanted Dunn. Despite climbing a 'mountain' of 1,200 feet and sliding down on his bottom, as he reported to Watts, he was now seriously ill. They returned to London in October and by November he was confined to his bed, unable to write. On 11 December he suffered a stroke which paralyzed his left side and Dr Henry Maudsley took up residence to administer morphine. By 4 February 1882 he had recovered sufficiently to travel to Birchington-on-sea, on the Kent coast, where his old friend John Seddon had lent him a bungalow. He still retained a sense of humour, writing to Watts on the 25th: 'I suppose my illness is notorious here, for today the Parson called, and when I was denied him by Caine, said he, "Thought I might wish to see [him]".' Rossetti died on 9 April, Easter Sunday, 1882, of Bright's disease.

Outline Biography

1828 Gabriel Charles Dante born in London on 12 May to Gabriele and Frances Rossetti.

1837 Attends King's College School.

1841 Attends Sass's Drawing Academy.

1846 Accepted by the Royal Academy Antique School.

1848 Becomes a pupil of Ford Madox Brown. Shares a studio with William Holman Hunt. Foundation of the Pre-Raphaelite Brotherhood.

1849 Shows *The Girlhood of Mary Virgin* (Plate 2) at the Free Exhibition. Visits Paris and the Low Countries with Hunt. First subject from Dante, *Dante Drawing an Angel on the First Anniversary of the Death of Beatrice* (Fig. 20).

1850 The P R Bs publish *The Germ*; the Brotherhood is under critical attack. Meets Elizabeth Siddal. Paints from nature at Sevenoaks.

1852 Moves to 14 Chatham Place, Blackfriars Bridge.

1854 Meets John Ruskin. Begins *Found* (Plate 6). Concern about Lizzie's health.

1855 Completed first Arthurian subject, *Arthur's Tomb: The Last Meeting of Launcelot and Guinevere* (Plate 7).

1856 Meets Fanny Cornforth. Llandaff altarpiece commission, *The Seed of David* (Plate 15). Meets Edward Burne-Jones and William Morris.

1857 Oxford Union decorations. Meets Jane Burden.

1858 Estrangement from Lizzie Siddal.

1859 Morris marries Jane Burden. Paints *Bocca Baciata* (Plate 18).

1860 The Red House is built. Marries Lizzie Siddal.

1861 Foundation of Morris, Marshall, Faulkner and Company. First stained-glass designs. Publication of *Early Italian Poets*.

1862 Suicide of Lizzie Siddal. Moves to Tudor House, 16 Cheyne Walk, Chelsea, which he shares with George Meredith and Algernon Swinburne.

1864 Paints *Beata Beatrix* (Plate 26). Visits Paris with Fanny Cornforth.

1865 The Morrises move to Queen Square Bloomsbury. Jane Morris poses for photographs. Meets Alexa Wilding.

1867 Employs Treffry Dunn. Suffers from eye trouble.

1868 Paints *Portrait of Mrs William Morris in a Blue Silk Dress* (Fig. 38). Begins affair with Jane Morris. Stays with William Bell Scott at Penkill Castle, Ayrshire.

1869 The Morrises go to Bad Ems, Germany. Stays at Penkill. Disinterment of manuscript poems.

1870 Stays with Jane Morris at Scalands. Publication of *Poems*.

1871 Takes joint tenancy of Kelmscott Manor, Gloucestershire, with Morris. Attacked in 'The Fleshly School of Poetry' by Robert Buchanan.

1872 Mental breakdown and attempted suicide. Recuperates in Scotland.

1873 Painting and writing at Kelmscott.

1874 Paints Jane Morris as *Proserpine* (Plate 42). Leaves Kelmscott Manor. Morris dissolves the Firm.

1875 Spends autumn in Bognor. Deeply depressed. Jane Morris sits for *Astarte Syriaca* (Plate 46).

1877 Ill, convalesces near Herne Bay. Estrangement from Brown until 1879. Addicted to drugs and alcohol. Financial problems.

1879 Paints Jane Morris as *The Day Dream* (Plate 48).

1881 Hall Caine resident at Tudor House. Publication of *Poems* and *Ballads and Sonnets*. Visits Keswick with Fanny Cornforth. Suffers a partial stroke.

1882 Convalesces at Birchington-on-sea. Dies on Easter Sunday, April 9.

Select Bibliography

All recent writers on Rossetti owe a great debt to Virginia Surtees whose *catalogue raisonné, The Paintings and Drawings of Dante Gabriel Rossetti*, was published in two volumes by Oxford University Press in 1971, and I should like to acknowledge my own dependence on her work. All quotations from Rossetti's correspondence are taken from *The Letters of Dante Gabriel Rossetti*, edited by O Doughty and J Wahl, four volumes, Oxford University Press, 1965 and 1967, and *D G Rossetti and Jane Morris: Their Correspondence*, edited by J Byron and J C Troxall, also published by Oxford University Press in 1976.

F G Stephens, *Dante Gabriel Rossetti*, London, 1894

W M Rossetti, *Dante Gabriel Rossetti: His Family Letters with a Memoir*, London, 1895

J W Mackail, *The Life of William Morris*, 2 vols, London, 1899

H C Marillier, *Dante Gabriel Rossetti*, London, 1899

W M Rossetti, *Ruskin: Rossetti: Pre-Raphaelitism*, London, 1899

W M Rossetti, *Pre-Raphaelite Diaries and Letters*, London, 1900

W M Rossetti, *The Rossetti Papers: 1862–1870*, London, 1903

G Burne-Jones, *Memorials of Sir Edward Burne-Jones*, 2 vols, London, 1904

H T Dunn, *Recollections of D G Rossetti and his Circle*, London, 1904

W Holman Hunt, *Pre-Raphaelitism and the Pre-Raphaelite Brotherhood*, 2 vols, London, 1906

W M Rossetti (ed.), *The Works of Dante Gabriel Rossetti*, 3 vols, London, 1911

E Waugh, *Rossetti*, London, 1928

O Doughty, *A Victorian Romantic: Dante Gabriel Rossetti*, London, 1949

R G Grylls, *Portrait of Rossetti*, London, 1964

W E Fredeman, *Pre-Raphaelitism: A Bibliocritical Study*, Cambridge, MA, 1965

T Hilton, *The Pre-Raphaelites*, London, 1970

A C Sewter, *The Stained Glass of William Morris and his Circle*, 2 vols, New Haven and London, 1974

V Surtees (ed.), *The Diary of Ford Madox Brown*, New Haven and London, 1981

L Parris (ed.), *The Pre-Raphaelites*, exhibition catalogue, Tate Gallery, London, 1984

N Kelvin (ed.), *The Letters of William Morris*, 4 vols, Princeton, NJ, 1984–95

P Faulkner, *Jane Morris – Letters to Wilfrid Scawen Blunt*, Exeter, 1986

J Marsh, *Jane and May Morris: A Biographical Story*, London, 1988

A C Faxon, *Dante Gabriel Rossetti*, London, 1989

T Newman and R Watkinson, *Ford Madox Brown and the Pre-Raphaelite Circle*, London, 1991

V Surtees, *Rossetti's Portraits of Elizabeth Siddal*, Oxford, 1991

J Marsh, *The Legend of Elizabeth Siddal*, London, 1992

F MacCarthy, *William Morris: A Life for our Time*, London, 1994

List of Illustrations

Colour Plates

Text Illustrations

1 Portrait of William Michael Rossetti
 1846. Pencil on paper, 25.5 x 20 cm. National
 Portrait Gallery, London

2 Portrait of Ford Madox Brown
 1852. Pencil on paper, 16.5 x 11.5 cm.
 National Portrait Gallery, London

3 Caricature of William Holman Hunt
 c1850. Pen and ink on paper, 18 x 11 cm.
 Birmingham Museum and Art Gallery

4 Caricature of John Everett Millais
 c1850. Pen and ink on paper, 18 x 11 cm.
 Birmingham Museum and Art Gallery

5 JOHN EVERETT MILLAIS
 Portrait of John Ruskin
 1854. Oil on canvas, 71.8 x 61 cm.
 Private collection

6 JOHN EVERETT MILLAIS
 Lovers by a Rose Bush
 1848. Pen and ink on paper, 18 x 11 cm.
 Birmingham Museum and Art Gallery

7 WILLIAM HOLMAN HUNT
 Study for A Converted British Family
 Sheltering a Christian Priest from the
 Persecution of the Druids
 1849. Pen and ink on paper, 22.8 x 29.8 cm.
 Johannesburg Art Gallery

8 WILLIAM HOLMAN HUNT
 Portrait of Dante Gabriel Rossetti
 1853. Oil on canvas, 29.2 x 21.5 cm.
 Birmingham Museum and Art Gallery

9 Rossetti Sitting to Elizabeth Siddal
 1853. Pen and ink on paper, 11 x 16.5 cm.
 Birmingham Museum and Art Gallery

10 ELIZABETH SIDDAL
 Lovers Listening to Music
 1854. Pencil, pen and ink on paper, 24 x 30 cm.
 Ashmolean Museum, Oxford

11 Maids of Elfen-mere
 1854. Engraving.
 Illustration to William Allingham's 'Maids of Elfen-
 mere' in Day and Night Songs (London, 1854)

12 St Cecilia
 1856–7. Pen and ink on paper, 9.6 x 8.2 cm.
 Birmingham Museum and Art Gallery

13 Sir Launcelot's Vision of the Sanc Grael
 1857. Watercolour on paper, 68 x 103.5 cm.
 Ashmolean Museum, Oxford

14 Portrait of Jane Burden, Aged 18
 1858. Pen, ink, pencil and wash with
 white highlights on paper, 49.2 x 37.6 cm.
 National Gallery of Ireland, Dublin

15 CHARLES LUTWIDGE DODGSON
 (LEWIS CARROLL)
 The Rossetti Family at Cheyne Walk
 (from left to right: D G Rossetti, Christina
 Rossetti, Frances Rossetti, William
 Michael Rossetti)
 1863. Photograph. National Portrait Gallery,
 London

16 Death of a Wombat
 1869. Pen and ink on paper, 18 x 11 cm.
 British Museum, London

17 Rupes Topseia
 c1875–80. Pen and ink on paper, 18 x 11 cm.
 British Museum, London

Comparative Figures

18 Self-portrait
 1855. Pen and ink on paper, 12 x 10.8 cm.
 Fitzwilliam Museum, University of Cambridge

19 Portrait of Elizabeth Siddal
 1854. Pencil, pen and ink on paper, 22.3 x 19 cm.
 Fitzwilliam Museum, University of Cambridge

20 Dante Drawing an Angel on the First
 Anniversary of the Death of Beatrice
 1849. Pen and ink on paper, 40 x 32.5 cm.
 Birmingham Museum and Art Gallery

21 Beatrice Meeting Dante at a Marriage
 Feast, Denies him her Salutation
 1852. Watercolour on paper, 35 x 42.5 cm.
 Private collection

22 St George and the Princess Sabra
 1862. Watercolour on paper, 52 x 30.7 cm.
 Tate Gallery, London

23 King Arthur and the Weeping Queens
 1856–7. Pen and ink on paper, 8 x 8.25 cm.
 Birmingham Museum and Art Gallery

24 Mary Magdalene at the Door of
 Simon the Pharisee
 1858. Pen and ink on paper, 54 x 47.7 cm.
 Fitzwilliam Museum, University of Cambridge

25 Study for the Head of David
 c1862. Pencil on paper, 24.7 x 22.2 cm.
 Birmingham Museum and Art Gallery

26 How They Met Themselves
 1860. Pen and ink and brush on paper, 26.5 x 21 cm.
 Fitzwilliam Museum, University of Cambridge

27 Portrait of Fanny Cornforth
 1859. Pencil on paper, 14 x 14.5 cm.
 Tate Gallery, London

28 Study for Dantis Amor
 1859–60. Pen and ink on paper, 25 x 24 cm.
 Birmingham Museum and Art Gallery

29 FORD MADOX BROWN
 Portrait of James Leathart
 1863–4. Oil on canvas, 34 x 28 cm. Family collection

30 FORD MADOX BROWN
 'Mauvais Sujet'
 1863. Oil on canvas. Size and location unknown

31 WILLIAM MORRIS
 La Belle Iseult
 1858. Oil on canvas, 71.7 x 50 cm.
 Tate Gallery, London

32 Study for Venus Verticordia
 c1863. Chalk on paper, 77.5 x 62 cm.
 Faringdon Collection Trust, Buscot Park,
 Oxfordshire

33 Study of the Black Boy for The Beloved
 1864–5. Chalk and pencil on paper, 50 x 36 cm.
 Birmingham Museum and Art Gallery

34 FREDERICK SANDYS
 Medea
 1868. Oil on panel, 62 x 46 cm.
 Birmingham Museum and Art Gallery

35 Lady Lilith
 1864–8. Oil on canvas, 95 x 81 cm.
 Samuel and Mary R Bancroft Memorial, Delaware
 Art Museum, Wilmington, DE

36 JOHN PARSONS
 Jane Morris
 1865. Photograph.
 Victoria and Albert Museum, London

37 The M's at Ems
 1869. Pen and ink on paper, 11 x 18 cm.
 British Museum, London

38 Portrait of Mrs William Morris in
 a Blue Silk Dress
 1868. Oil on canvas, 110.5 x 90 cm. Society of
 Antiquaries, Kelmscott Manor, Gloucestershire

39 CHARLES MARCH GERE
 View of the East Front of Kelmscott Manor
 1892. Woodcut (by W H Hooper).
 Frontispiece to News from Nowhere (London, 1892)

40 Study of Dancing Girls for
 The Bower Meadow
 1872. Chalk on paper, 42 x 35 cm.
 Birmingham Museum and Art Gallery

41 Sancta Lilias
 1874. Oil on panel, 48 x 45.7 cm.
 Tate Gallery, London

1 Self-portrait

1847. Pencil heightened with white on paper, 19 x 19.6 cm. National Portrait Gallery, London

Fig. 18
Self-portrait
1855. Pen and ink on
paper, 12 x 10.8 cm.
Fitzwilliam Museum,
University of Cambridge

This self-portrait, drawn when Rossetti was 18 years old and a student at the Antique School of the Royal Academy, is self-consciously romantic; the Bohemian flowing locks clearly signify his artistic and poetic aspirations. According to F G Stephens, his contemporary and first biographer, Rossetti's dress and manner were 'the outward visible signs of a mind which cared even less for appearances than the art student of those days was accustomed to care, which undoubtedly was little enough'. Rossetti was never considered to be conventionally handsome, 'Meagre in youth', wrote his brother William, 'he was at times decidedly fat in middle age'; his personality, rather than his appearance, was attractive. According to Wilfrid Scawen Blunt, Jane Morris's later lover, she said of Rossetti: 'If you had known him you would have loved him, and he would have loved you – all were devoted to him who knew him. He was unlike all other men.' Despite her partiality, more objective evidence suggests that her statement was largely accurate.

In relation to later self-portraits, such as the one executed eight years later (Fig. 18), this early work is probably flattering. He gave it to his Aunt Eliza Polidori, although whether or not it was originally intended as a gift for her is not known.

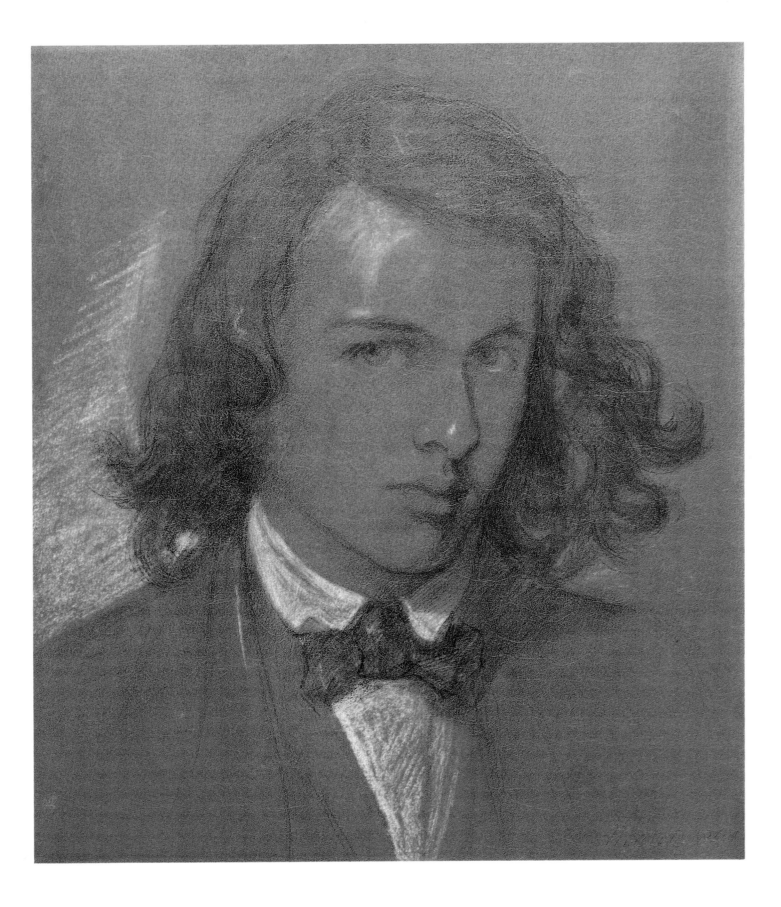

2 The Girlhood of Mary Virgin

1849. Oil on canvas, 83 x 65 cm. Tate Gallery, London

Rossetti's first completed oil painting contains many of the elements which characterize his later work, albeit naïvely. The picture overflows with symbolism, both traditional and personal. The lily, an emblem of purity and also an attribute of the Angel Gabriel, stands on a pile of books which bear the names of the three theological virtues, Faith, Hope and Charity, and three of the four cardinal virtues, Prudence, Fortitude and Temperance. The entwined palm and thorn in the foreground foretell the Passion, the crimson cloth on the balustrade, which bears in its centre two sides of a triangle with symbols of the Trinity and the Holy Ghost, represents Christ's robe, while behind it the trellis forms a cross, bound with ivy, a metaphor peculiar to Rossetti with which he represented 'clinging memory'. Behind the balcony the somewhat insubstantial figure of St Joachim, Mary's father, tends the vine, a traditional symbol of Christ. The haloed dove seated on the trellis represents the Holy Ghost and the rose, in the jar to the left, is a familiar attribute of the Virgin. Rossetti has also inscribed the names of his subjects within their halos, a practice he may have adopted from Benozzo Gozzoli. In the background lies the Lake of Galilee in a landscape which owes a debt to fifteenth-century Italian paintings.

The Virgin appears to have adopted Pre-Raphaelite principles in practising the rare art of embroidery from life.

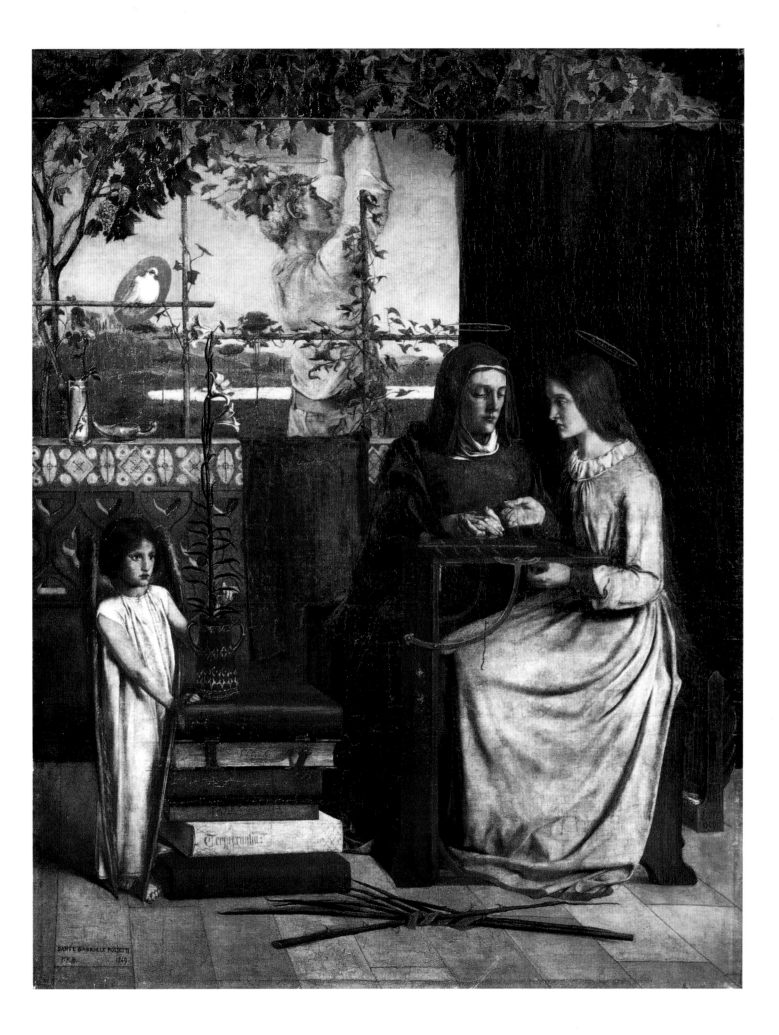

3 Ecce Ancilla Domini! (The Annunciation)

1850. Oil on canvas, 73 x 42 cm. Tate Gallery, London

This painting, Rossetti's last publicly exhibited work, shows a great improvement on *The Girlhood of Mary Virgin* (Plate 2) with which it is linked by the now completed embroidery. It is a genuinely original and arresting portrayal of the Annunciation, unlike any Renaissance prototype, and he has managed to curb his enthusiasm for excessive symbolism. As before the Virgin was posed for by Christina Rossetti, although her reddish golden hair was painted from Miss Love, a professional model. Fearing criticism on the grounds of indecency, William, who modelled for the angel, excused Mary's dishabille on account of the warm climate of the Holy Land.

Rossetti had a fondness for Latin titles, but this one was changed to 'The Annunciation' shortly after completion to remove any suspicion of Roman Catholicism. In 1874, when he retouched the painting for his patron William Graham, he wrote to Ford Madox Brown, 'I have got the little "Annunciation" – Alas! In some of the highest respects I have hardly done anything else so good.'

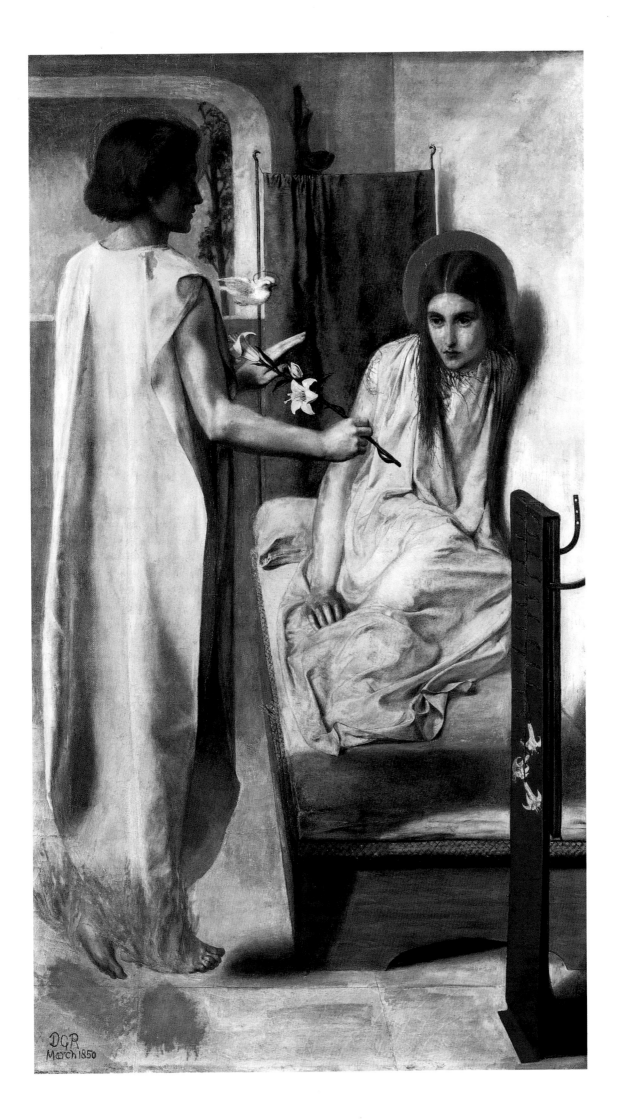

4 Portrait of Elizabeth Siddal

1850–65. Watercolour on paper, 33 x 24 cm. Fitzwilliam Museum, University of Cambridge

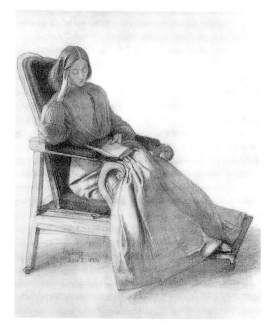

Fig. 19
Portrait of
Elizabeth Siddal
1854. Pencil, pen and ink
on paper, 22.3 x 19 cm.
Fitzwilliam Museum,
University of Cambridge

The date on the painting is ambiguous, but suggests that it was begun in 1850, the year that Rossetti and Lizzie first met, when she was 21. According to William, admittedly writing much later, 'She was a most beautiful creature … tall, finely formed, with a lofty neck, and regular yet somewhat uncommon features, greenish blue unsparkling eyes, large perfect eyelids, brilliant complexion, and a lavish heavy wealth of coppery-golden hair.' Rossetti was well known for abandoning works and returning to them years later, but it is hard to understand how such a relatively simple drawing could need reworking, possibly the gold ground was added in 1865. In her *catalogue raisonné* Virginia Surtees speculates that the dates may signify the period during which Lizzie's features dominated his work, and lists 58 extant drawings of her done between 1850 and 1861, the year of her death. Significantly there are no drawings of her between October 1856 and 1860, the period of difficulties in their relationship and their estrangement. In this early drawing she is full-faced and shows no sign of illness, in contrast to the drawing done during her convalescence at Hastings in 1854, in which her own debility is echoed in Rossetti's delicacy of execution (Fig. 19).

The First Anniversary of the Death of Beatrice: Dante Drawing the Angel

1853. Watercolour on paper, 42 x 61 cm. Ashmolean Museum, Oxford

Fig. 20
Dante Drawing an
Angel on the First
Anniversary of the
Death of Beatrice
1849. Pen and ink on
paper, 40 x 32.5 cm.
Birmingham Museum
and Art Gallery

The composition differs completely from the angular Pre-Raphaelite drawing of the same subject (Fig. 20), which Rossetti gave to Millais in 1849, although archaic musical instruments, a passion of Rossetti's, appear in both. In the *Vita nuova*, Dante recalls how he drew an angel on the anniversary of Beatrice's death: 'and while I did this, chancing to turn my head, I perceived that some were standing beside me to whom I should have given courteous welcome, and that they were observing what I did ... perceiving whom, I arose for salutation, and said: "Another was with me".' The face of the young woman is that of Lizzie Siddal and the older man was probably posed for by 'Old Williams'. The spatial treatment, with receding parallel planes leading finally to glimpses of landscape and improbable architecture are typical of his watercolours of the 1850s, although this picture, with the River Arno seen through the window and the sunlit trees beyond the door, is far less claustrophobic than those of the later 1850s. It was bought by Francis MacCracken, who had also purchased *Ecce Ancilla Domini!* (Plate 3), and shown by him to John Ruskin, which led to the first meeting of the critic and the painter.

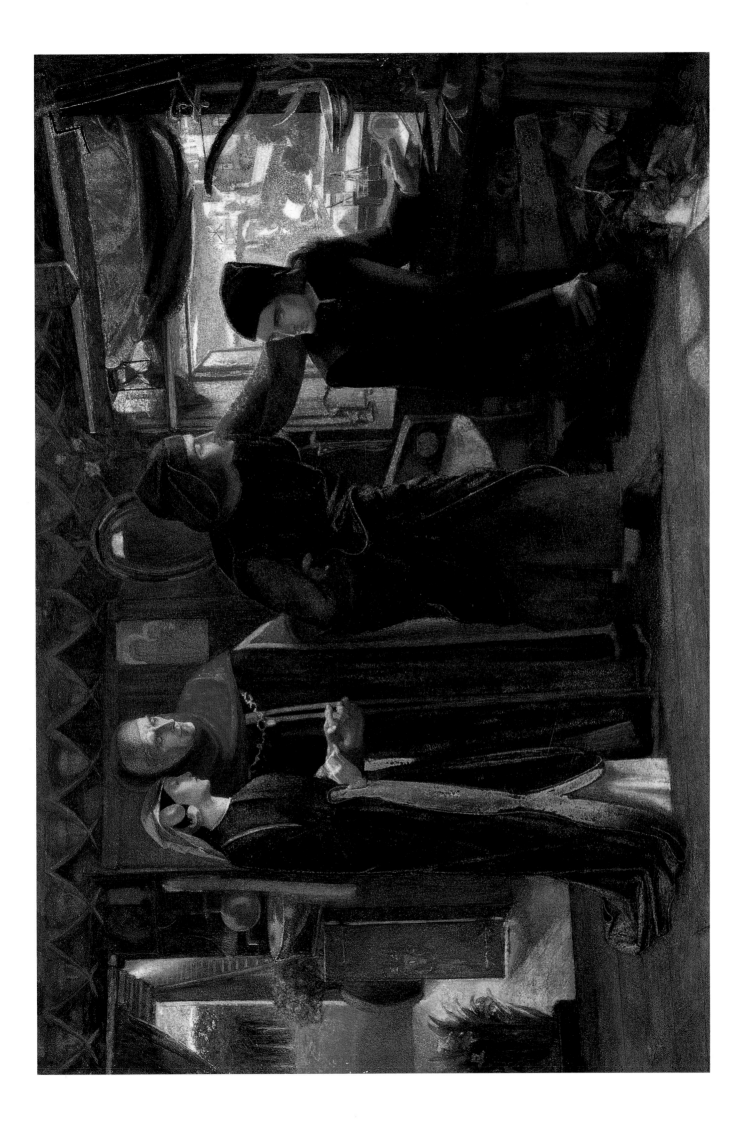

6 Found

Begun 1854. Oil on canvas, 91.5 x 80 cm. Samuel and Mary R Bancroft Memorial, Delaware Art Museum, Wilmington, DE

Rossetti's attempt at a 'modern' subject, a preoccupation of the Brotherhood in 1852 to 1854, was to cause him and Brown, and his patrons MacCracken, Leathart and Graham, considerable difficulty; it remained unfinished at his death almost 30 years later, when it was completed by Edward Burne-Jones and Treffry Dunn. The subject, inspired by William Bell Scott's poem 'Rosabell', later retitled 'Maryanne', is that of a prostitute recognized by her former fiancé, a young farmer, while taking a calf to market over Blackfriars Bridge. She cowers beside the wall of a graveyard, symbolizing death and, unless she repents, damnation.

Having painted the wall in Chiswick, Rossetti arrived at the Browns' house on 31 October 1854 in Hendon to paint the calf. Apart from a short break at Christmas he remained there until January 1855, monopolizing the sitting room, borrowing Brown's clothes, abusing their hospitality and criticizing their young daughter Catherine. Although he worked on the picture spasmodically for the rest of his life, technical difficulties, particularly the perspective, defeated him.

He returned to the theme in 1857, again inspired by Bell Scott's verse, with the watercolour *The Gate of Memory* (Private collection), and his own poem, 'Jenny', published in 1870, also deals with the issue of prostitution.

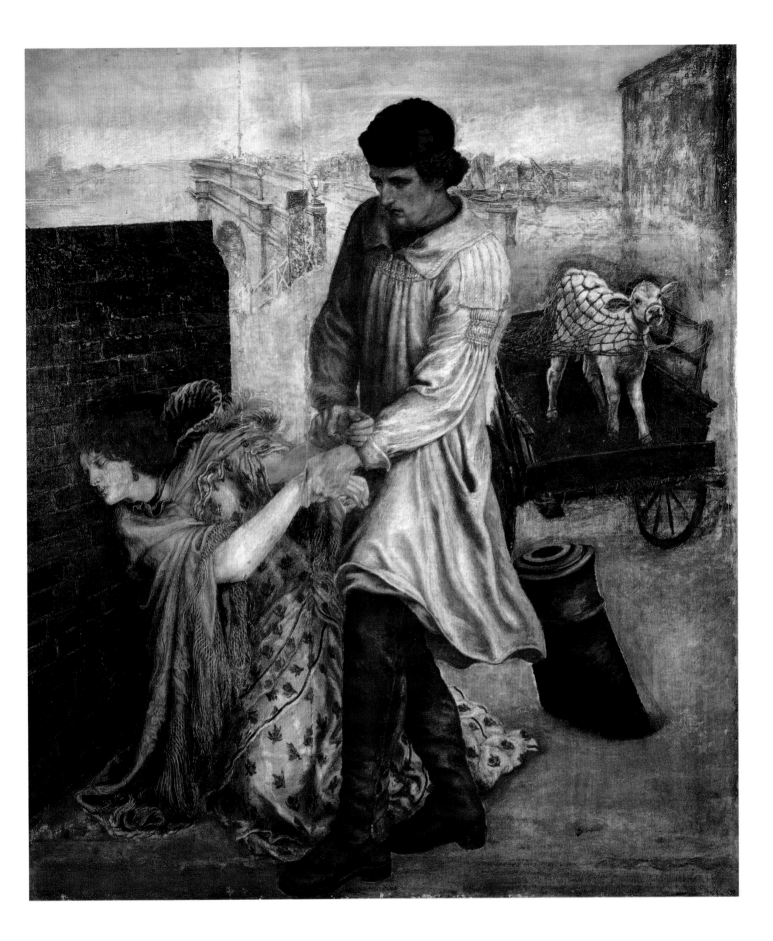

7 Arthur's Tomb: The Last Meeting of Launcelot and Guinevere

1854. Watercolour on paper, 23.5 x 36.8 cm. British Museum, London

Although it is dated 1854, this painting, Rossetti's first treatment of an Arthurian subject, was completed towards the end of 1855 when, according to William, he was reading Malory's *Morte d'Arthur*. The subject, however, in which the repentant Queen repulses Launcelot's attempt to kiss her over her late husband's tomb, was his own invention. In Malory's work the Queen rejects Launcelot at Almesbury, where she has retired to a nunnery, whereas Arthur was buried at Glastonbury. The dominating apple tree and the snake, creeping out of the grass in the lower left-hand corner, are clear references to the biblical Fall of Man. The angularity of both figures, particularly the Queen who was surely posed for by Lizzie Siddal, harks back to the early P R B style of 1849–50. The picture, which was purchased by Ruskin, inspired the poem of the same title by William Morris in *The Defence of Guinevere*, his first volume of poetry, published in 1858.

> Across my husband's head, fair Launcelot!
> Fair serpent mark'd with V upon the head!
> This thing we did while yet he was alive,
> Why not, O twisting Knight, Now he is dead?

(From 'Arthur's Tomb', William Morris)

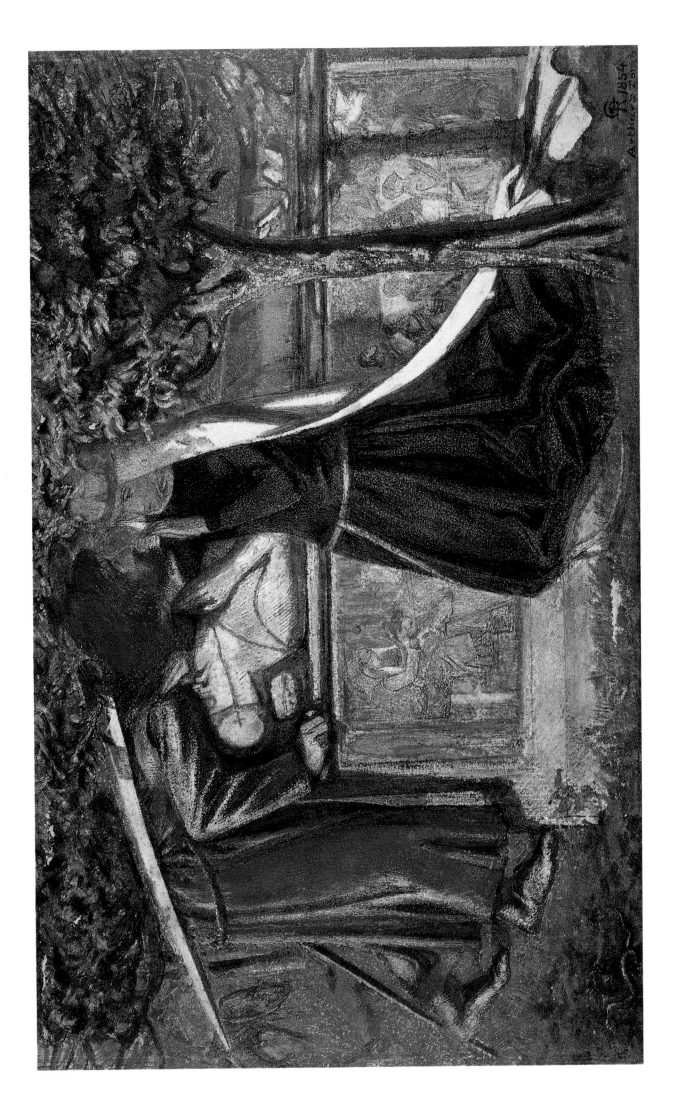

Beatrice Meeting Dante at a Marriage Feast, Denies him her Salutation

1855. Watercolour on paper, 34 x 42 cm. Ashmolean Museum, Oxford

This watercolour is a replica, commissioned by John Ruskin, of a painting of 1852 (Fig. 21). The original was the second of his subjects from the *Vita nuova*, the first being *Dante Drawing an Angel on the First Anniversary of the Death of Beatrice* (Fig. 20). According to a letter to his godfather, the Dante scholar Charles Lyell, written in November 1848, Rossetti intended to illustrate the work with ten original drawings, but never completed the series.

Dante, supported by a friend, and oblivious to the small girl offering him a flower, stares fixedly at the haughty Beatrice directly behind her, who fails to acknowledge him. The lively composition is full of movement and activity, from the grape pickers in the lower left to the musicians on the balcony, glimpsed through the doorway.

The face of Beatrice is taken from Elizabeth Siddal, who he had first met in 1850. The painting was purchased from an exhibition held by Rossetti's dealer Ernest Gambart for £10 by H T Wells, a fellow artist, in the winter of 1852. Rossetti borrowed the original from Wells to paint this copy for Ruskin who, typically, objected to the face of one of the bridesmaids and, having asked Rossetti to alter it, was dismayed when he erased the head completely prior to repainting it; Ruskin was perpetually alarmed by Rossetti's incautious technical methods.

Fig. 21
Beatrice Meeting
Dante at a Marriage
Feast, Denies him
her Salutation
1852. Watercolour on
paper, 35 x 42.5 cm.
Private collection

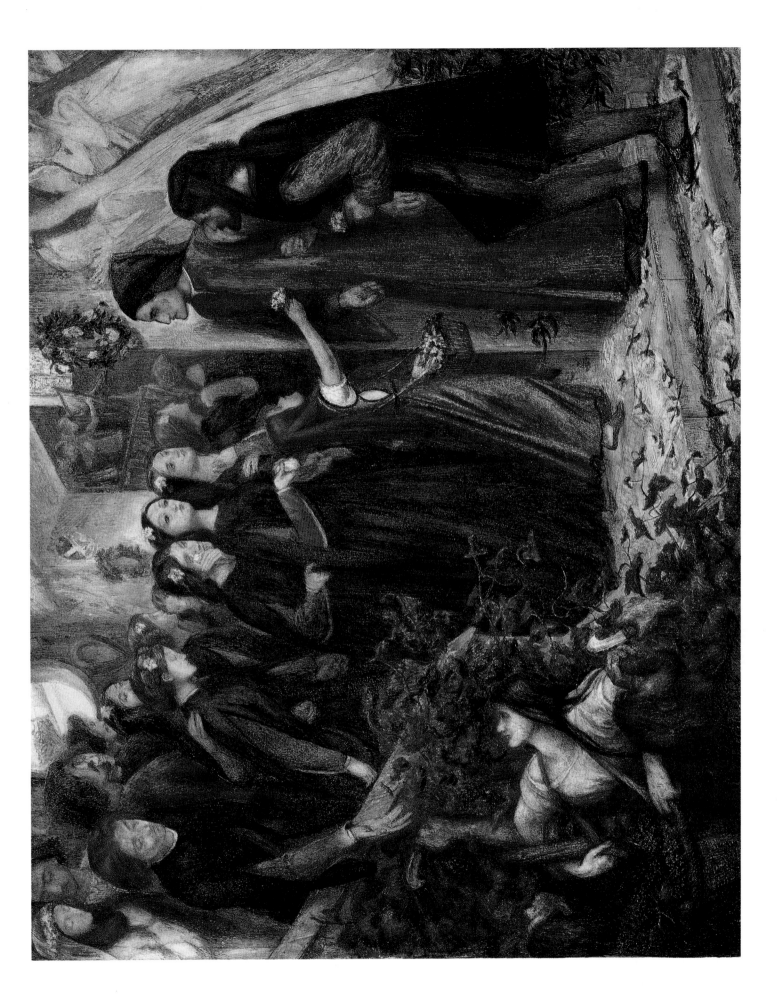

Dante's Vision of Rachel and Leah

1855. Watercolour on paper, 35.5 x 31.5 cm. Tate Gallery, London

48

The subject, taken from Dante's *Purgatorio*, Canto XXVII, was one of six suggested by Ruskin. Two were completed, the other being *Dante's Vision of Matilda Gathering Flowers* (location unknown). It is quite possible that Ruskin, conscious of Rossetti's morbidity, was deliberately attempting to influence him towards more pastoral and peaceful themes. Dante, guided through purgatory by Virgil, dreams of a meadow where Rachel, posed for by Lizzie Siddal, sits on a stone basin above a stream looking at her reflection in the water, while her sister Leah collects branches of honeysuckle with which to make a garland. The figure walking in front of the copse in the left background is Dante. The basin and the tunnel through which the stream flows are typical of Rossetti's bizarre architectural fancies. Ruskin, who paid 30 guineas for the watercolour rather than the 20 asked for, passed the picture to Ellen Heaton, another early patron. Although he commented on Rachel's awkward pose he considered it 'very lovely' and 'Pre-Raphaelite' and added that Rossetti 'likes it very much himself'.

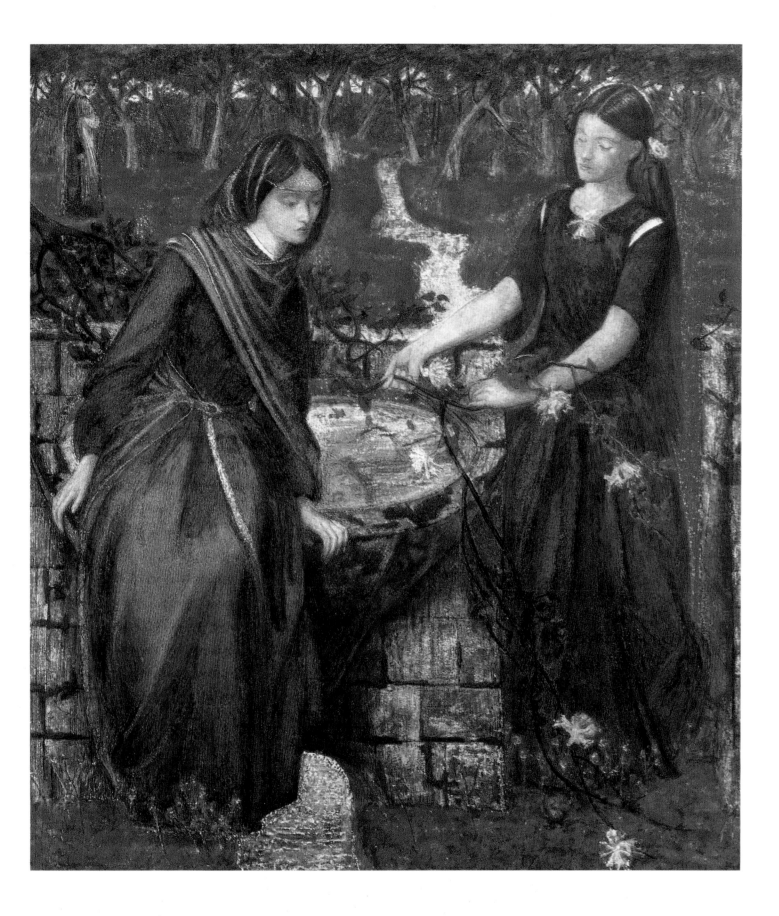

The Blue Closet

1857. Watercolour on paper, 34.3 x 24.8 cm. Tate Gallery, London

50

This was one of several watercolours, including *The Tune of Seven Towers* (Plate 12), purchased by William Morris in 1857, the year after he and Rossetti first met. Rossetti was at his most prolific in 1857 and the watercolours of this period are arguably his finest and most original works. The subject has no apparent literary source; two women play upon a strange medieval instrument, which combines clavichord, carillon and harp. The sprigs of holly entwined around the top of the instrument may be an indication of the festive season. Behind the musicians, pressed to the walls which, like the floor, are tiled in blue, stand two female singers; in the centre foreground a red lily grows from a square hole in the tiles. Despite the symmetry and clarity of the composition, the overall mood is mysterious, melancholic and claustrophobic. The painting inspired Morris's poem of the same name but, as Rossetti remarked, 'The poems were the result of the pictures, but don't at all tally to any purpose with them though beautiful in themselves.'

Lady Alice, Lady Louise,
 Between the wash of the tumbling seas
We are ready to sing, if so ye please;
 So lay your long hands on the keys;
Sing, Laudate pueri.

(From 'The Blue Closet', William Morris)

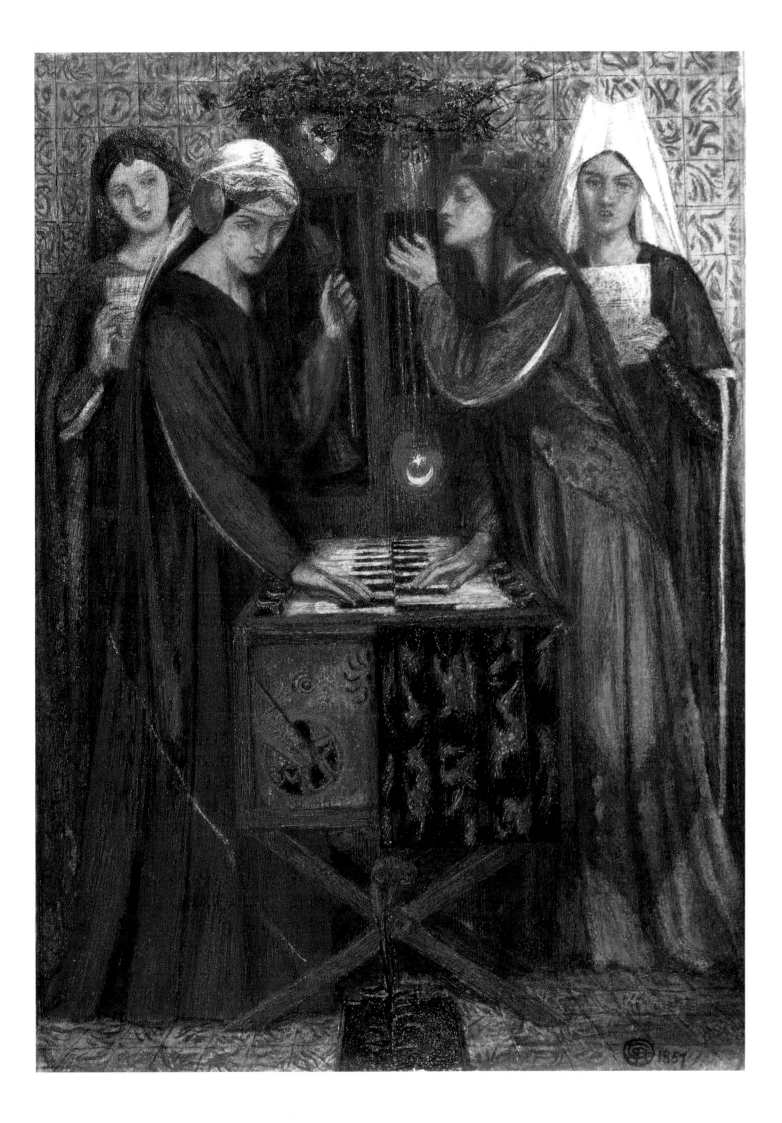

11 The Wedding of St George and the Princess Sabra

1857. Watercolour on paper, 36.5 x 36.5 cm. Tate Gallery, London

Fig. 22
St George and the
Princess Sabra
1862. Watercolour on
paper, 52 x 30.7 cm.
Tate Gallery, London

St George, seated in an emblazoned woven chair, embraces the kneeling princess who is cutting off a lock of her long dark hair as a pledge to her rescuer. Behind them, framed by an aperture in the wooden wall, two green-winged angels play upon a carillon and, in the right foreground, the head of the slain dragon emerges from a wooden crate. In the top centre of the picture a crown hangs from a hook, a Rossettian fancy which also appears in *Sir Launcelot in the Queen's Chamber*, 1857 (Birmingham Museum and Art Gallery), and at the extreme right is a copper water dispenser, which next appears in *La Bella Mano* (Plate 44) almost 20 years later.

Rossetti returned to the story of St George in 1861 and 1862 when he designed six cartoons for stained glass for Morris, Marshall, Faulkner and Company and painted a further watercolour, *St George and the Princess Sabra* (Fig. 22). The principal interest in this rather pedestrian later work is the stencilled diaper pattern on the wall, which incorporates trees, and may be a variant of his unexecuted wallpaper design for Chatham Place, described to William Allingham in 1861. Morris, too, was designing his first wallpapers in 1862, although they were not manufactured until 1864.

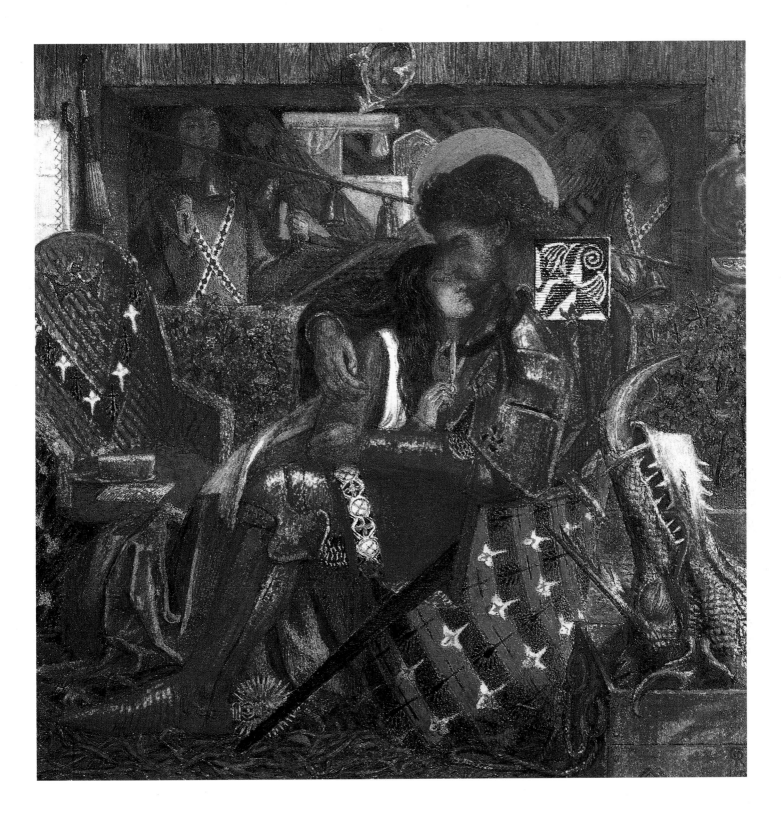

1857. Watercolour on paper, 31.4 x 36.5 cm. Tate Gallery, London

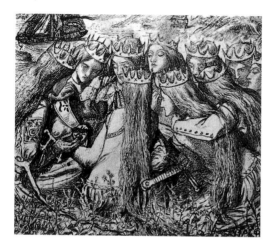

Fig. 23
King Arthur and the
Weeping Queens
1856–7. Pen and ink
on paper, 8 x 8.25 cm.
Birmingham Museum and
Art Gallery

This intense small painting is probably the oddest of the watercolours painted in 1857. The architecture is stranger and more claustrophobic than ever; there is box within box, and the left-hand three-quarters of the picture surface is crossed diagonally by a lance bearing a pennant, which effectively imprisons the principal figures. Once again the subject is invented by Rossetti; a king listens raptly to the music played by his queen on a zither that is incorporated into her chair, the back of which rises to form a miniature belfry. To her right stands another woman, equally enthralled by the music, and behind her a hole in the wall reveals a bird on a staircase. Behind the king and queen a servant, wearing the same strange bonnet as the female lover in *How They Met Themselves* (Fig. 26), leans through a shutter to strew orange boughs on an alcoved bed. The bizarre composite furniture that appears in Rossetti's paintings of this period may have been influenced by Morris and Webb, who, in 1856, were designing and making archaic furniture for Morris's rooms in Red Lion Square. Rossetti thought it wonderful, and humorously described it in a letter to William Allingham as 'like incubi and succubi', an epithet which could well be applied to the furniture in this picture.

The general medievalism of his subjects was probably encouraged by his work on Moxon's illustrated Tennyson during 1856 and 1857, including *King Arthur and the Weeping Queens* (Fig. 23), in which he greatly exaggerated the number of queens specified by Tennyson.

> Three Queens with crowns of gold –
> And from them rose
> A cry that shiver'd to the tingling stars,
> And, as it were one voice an agony
> Of lamentation …

(From 'Morte d'Arthur', Alfred Tennyson)

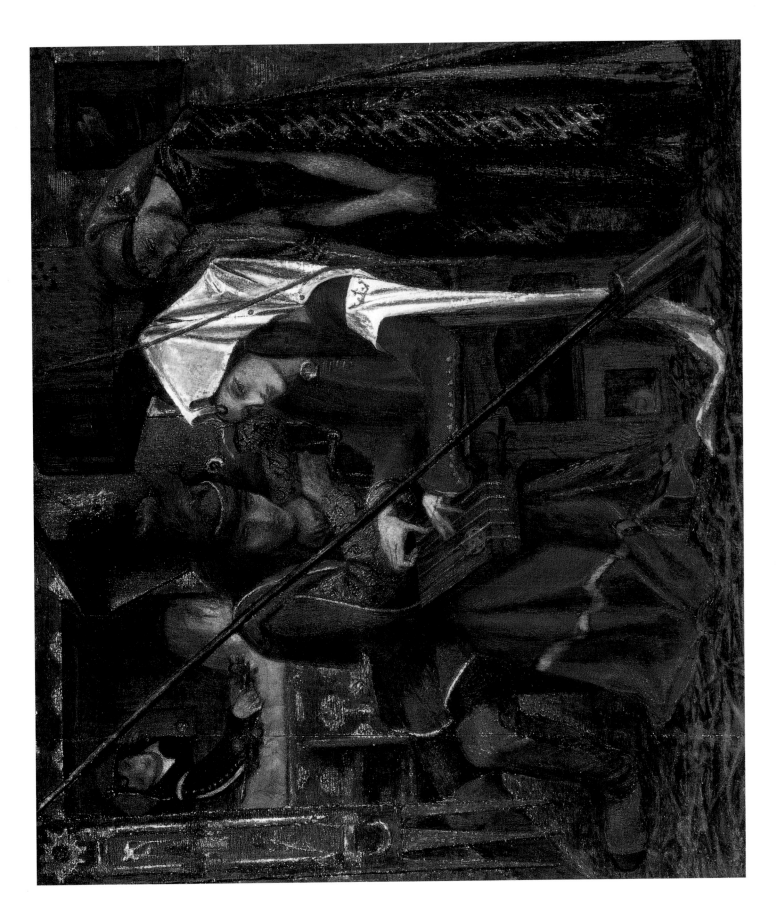

St Catherine

1857. Oil on canvas, 34.3 x 24.1 cm. Tate Gallery, London

Fig. 24
Mary Magdalene at
the Door of Simon the
Pharisee
1858. Pen and ink on
paper, 54 x 47.7 cm.
Fitzwilliam Museum,
University of Cambridge

St Catherine, commissioned by Ruskin who possibly suggested the subject, was Rossetti's first oil painting since 1853 and clearly demonstrates the superiority of his watercolour technique during this period. The subject is set in a medieval studio and shows an artist painting a model as St Catherine, identifiable by her attribute, the wheel. In the background apprentices study the preliminary drawing for a painting of the martyrdom of St Sebastian.

The picture was disliked by Ruskin, who later attempted, unsuccessfully, to exchange it for the magnificent drawing, *Mary Magdalene at the Door of Simon the Pharisee* (Fig. 24), completed in 1859, which Rossetti had been working on for over five years. Mary, having caught a glimpse of Christ seated inside Simon's house, turns aside from the worldly festivities to which she had been invited and attempts to reach her Master.

> Oh loose me! Seest thou not my Bridegroom's face
> That draws me to Him? For His feet my kiss,
> My hair, my tears He craves today: – and oh!
> What words can tell what other day and place
> Shall see me clasp these blood-stained feet of His?
> He needs me, calls me, loves me: let me go!

(From 'Mary Magdalene at the Door of Simon the Pharisee', Dante Gabriel Rossetti)

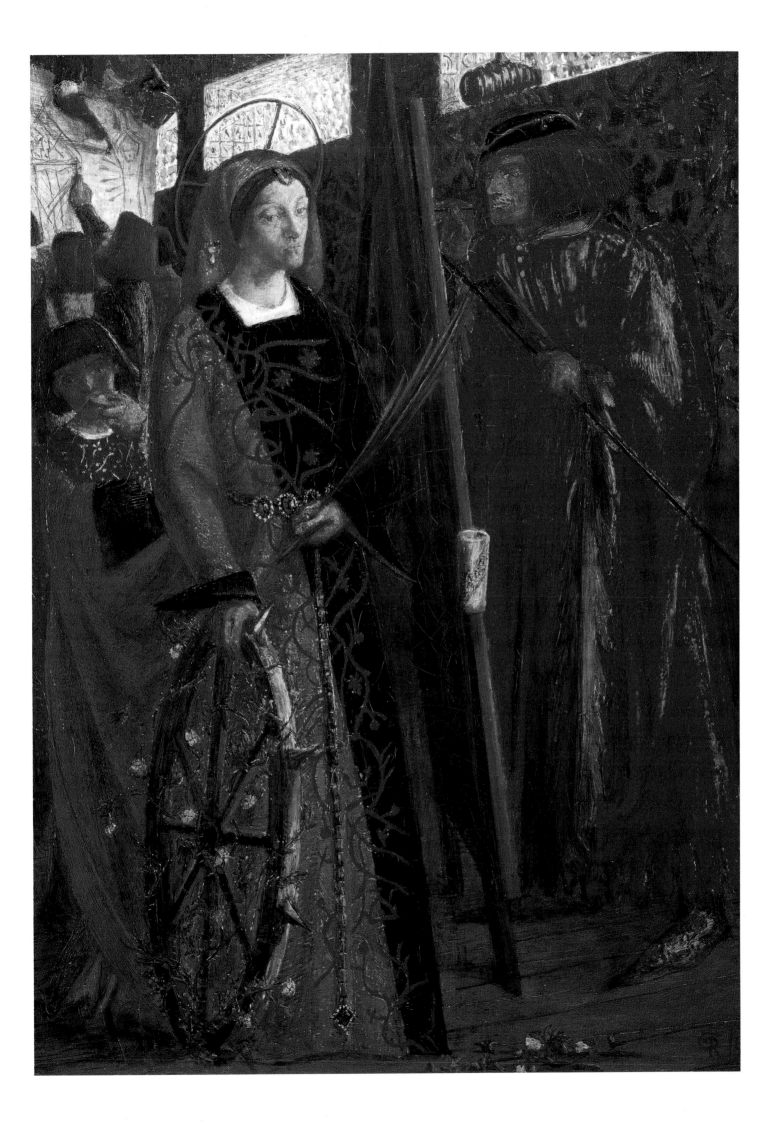

A Christmas Carol

1857–8. Watercolour and gouache on paper, mounted on panel, 34.3 x 29.7 cm. Fogg Museum of Art, Harvard University, Cambridge, MA

This painting is another variant on a musical theme, with a similar symmetry to *The Blue Closet* (Plate 10). The central figure, modelled by Lizzie Siddal, sits in a fantastical chair that incorporates a keyboard instrument and rises to form an open cupboard in which sits her crown. Her hair is being dressed by two attendant women, the one on the left combs it while her companion reaches for oil or perfume in the storage space in the chair back. Holly bushes in tubs at either side of the composition signify Christmas, as does the shallow box hanging before her instrument, which contains images of the Annunciation and the Nativity. The picture was bought by James Leathart, who was told by Rossetti, 'To be seen favourably the Carol ought to be hung with the light from the left, i.e. of the spectator.'

The painting inspired the following verse by Swinburne, who first met Rossetti during the decoration of the Oxford Union in 1857 when he was an undergraduate at Balliol.

Three damsels in the Queen's chamber,
 The Queen's mouth was most fair;
She spake a word of God's mother
 As the combs went in her hair.
'Mary that is of might,
 Bring us to thy Son's sight.'

(From 'A Christmas Carol: Suggested by a drawing by Mr D G Rossetti', Algernon Charles Swinburne)

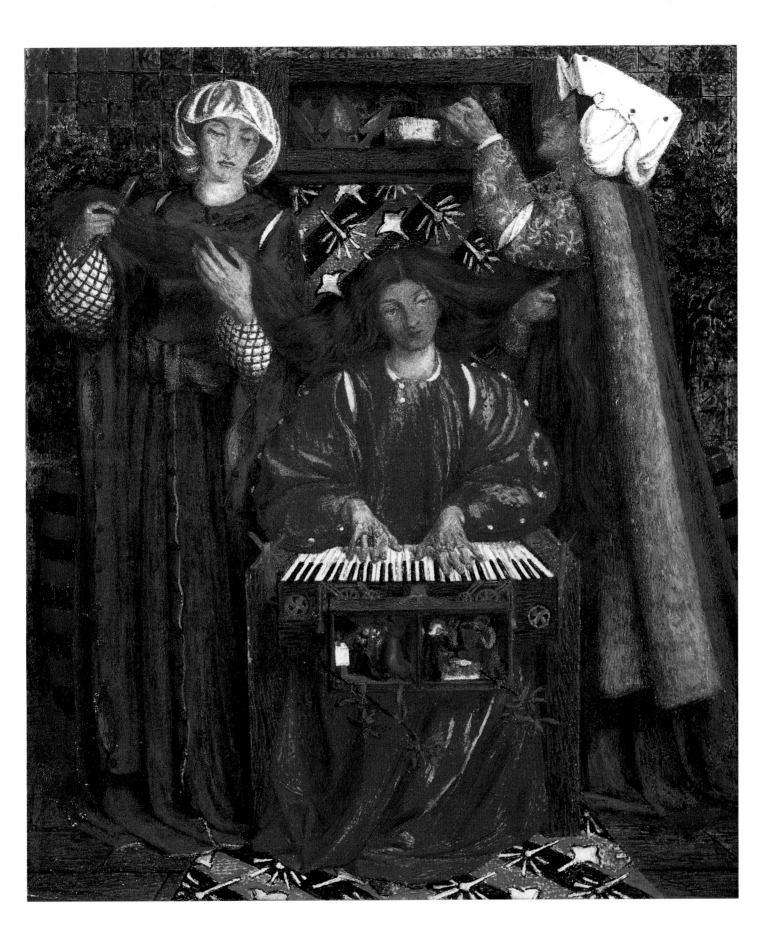

The Seed of David

1858–64. Oil on canvas, centre panel of triptych 228.5 x 152 cm, wings 185 x 62 cm.
Llandaff Cathedral, Cardiff

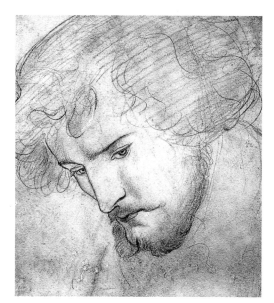

Fig. 25
Study for the Head
of David
*c*1862. Pencil on paper,
24.7 x 22.2 cm.
Birmingham Museum
and Art Gallery

Rossetti's only public commission was secured for him by John Seddon, the brother of Thomas Seddon, Rossetti's friend who had died in Cairo in 1856. Seddon, an architect, was engaged on the restoration of Llandaff Cathedral and commissioned an altarpiece from Rossetti for £400. During the negotiations Rossetti met Henry Austin Bruce, the local Member of Parliament, who, as Home Secretary, was later to assist him over the disinterment of his poems from Lizzie Siddal's grave.

The symbolism is based on David's dual identities of shepherd and king, which are shown in the side panels, and the worship of the infant Jesus by both kings and shepherds, depicted in the centre panel. The picture owes several debts to Italian Renaissance paintings, particularly the angel musicians in the stable loft which may derive from Botticelli's *Mystic Nativity* (National Gallery, London). Sandro Botticelli (*c*1445–1510) was a painter Rossetti greatly admired; in 1865, the year after completing the altarpiece, he purchased a Botticelli portrait of a woman, Esmeralda Bandinelli, from the sale of the Pourtales collection at Christie's, for £20. The year before he died, Rossetti sold it to Constantine Ionides for £315; the painting is now in the Victoria and Albert Museum, London.

William Morris posed for the head of David the King (Fig. 25), and Jane Morris's head was substituted for that of Ruth Herbert, an actress, who had originally sat for Mary.

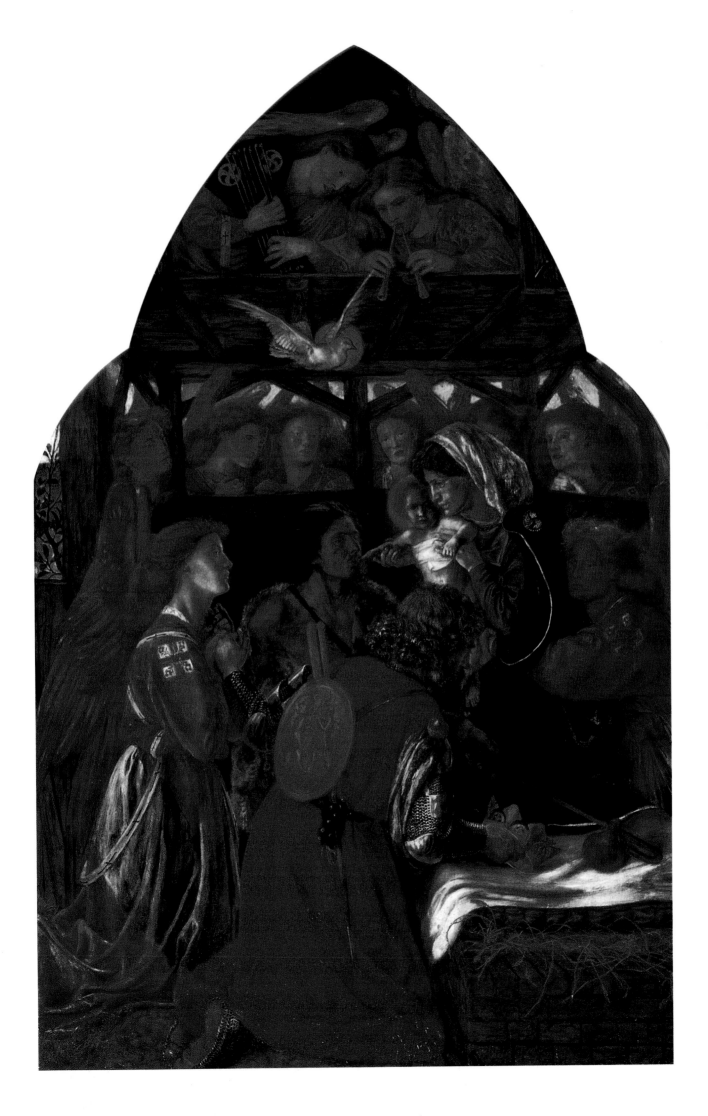

1859. Watercolour on paper, 26.5 x 24 cm. British Museum, London

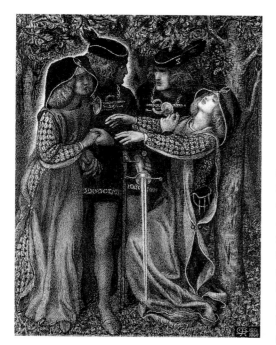

Fig. 26
How They Met
Themselves
1860. Pen and ink and
brush on paper,
26.5 x 21 cm.
Fitzwilliam Museum,
University of Cambridge

This strangely informal watercolour was painted as a gift for Ruth Herbert, who sat to Rossetti for a number of paintings in 1858. The subject is that of two lovers walking on a beach on a windy day. The man, whose wide-awake hat has blown off, momentarily stops his companion while he sketches a rough profile of her in the sand with the tip of his walking stick. The background was copied from two studies of the Devon coast at Babbacombe, by Rossetti's friend, the landscape painter George Price Boyce, who lent them to him.

The subject is generally considered to be entirely carefree, but the symbolism of a drawing in sand, which will disappear when the tide rises if it has not already been obliterated by the wind, suggests the ephemerality of either love or beauty, and can hardly have escaped Rossetti's notice. Lovers are seldom happy in his work and in his famous 'bogie' drawing, *How They Met Themselves* (Fig. 26), given to George Price Boyce in 1860 to replace an earlier version that had been either lost or accidentally destroyed, they are literally about to die, having met their doppelgängers. This was a subject Rossetti also developed in his unfinished prose tale, 'St Agnes of Intercession', begun in 1847 and abandoned in 1850, the supposed date of the original drawing.

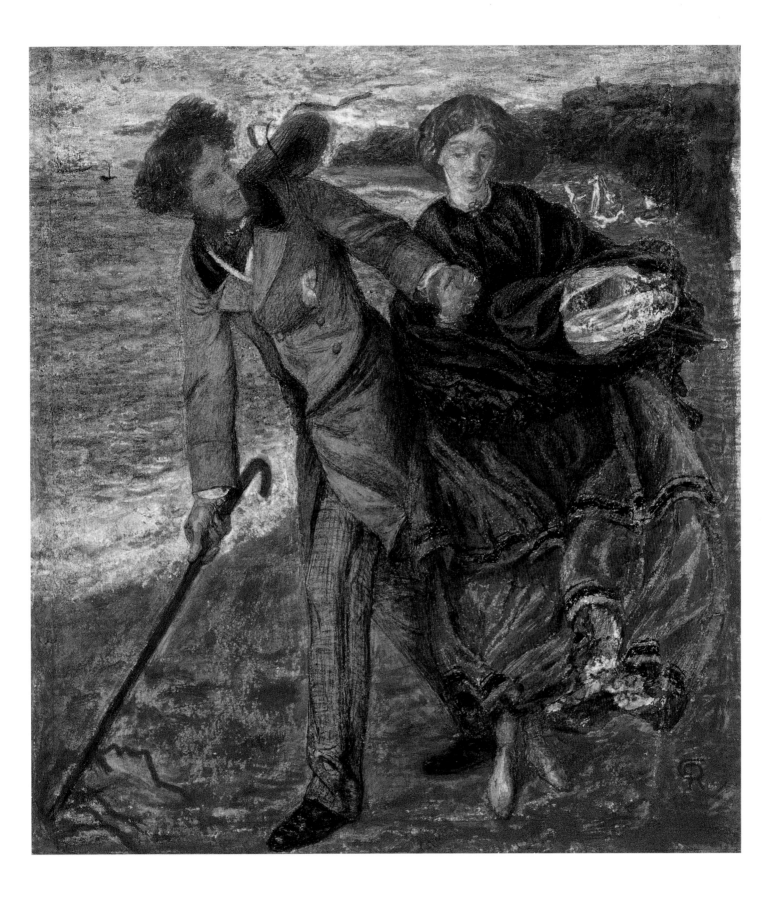

Sir Galahad at the Ruined Chapel

1859. Watercolour and bodycolour on paper, 29.1 x 34.5 cm. Birmingham Museum and Art Gallery

Sir Galahad at the Ruined Chapel is a watercolour version of an 1857 illustration for Moxon's Tennyson and it has much in common with the watercolours which Rossetti painted in that year. Despite its outdoor setting a sense of claustrophobia, so evident in *The Tune of Seven Towers* (Plate 12), is evoked by the angelic choir, virtually trapped beneath the rustic altar on which Sir Galahad leans. The lance and pennant dividing the picture surface is another obvious link between the two paintings. However, the most remarkable feature is the extraordinary, indeed alarmingly, vivid colour that is virtually luminescent, which is unique in Rossetti's work.

> Between dark stems the forest glows,
> I hear a noise of Hymns:
> Then by some secret shrine I ride;
> I hear a voice but none are there;
> The stalls are void, the doors are wide,
> The tapers burning fair.
> Fair gleams the snowy altar-cloth,
> The silver vessels sparkle clean,
> The shrill bell rings, the censer swings,
> And solemn chaunts resound between.

(From 'Sir Galahad', Alfred Tennyson)

Bocca Baciata

1859. Oil on panel, 32.2 x 27.1 cm. Museum of Fine Arts, Boston, MA

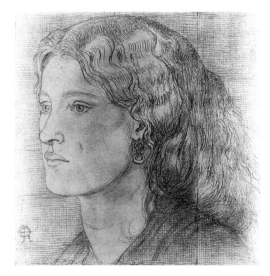

Fig. 27
Portrait of Fanny
Cornforth
1859. Pencil on paper,
14 x 14.5 cm.
Tate Gallery, London

This small painting, barely more than a foot square, proved to be a turning-point in Rossetti's development as an artist and his final rejection of Pre-Raphaelite techniques and principles. He was no longer concerned with morally elevating subjects and from now on the majority of his pictures were portraits of beautiful, bejewelled women usually alone and usually of bust or three-quarter length, with fanciful titles in Latin or Italian. 'Bocca Baciata' is a quotation from the fourteenth-century Italian poet and writer, Giovanni Boccacio, which Rossetti inscribed on the back of the painting; in full it reads: 'The mouth that has been kissed loses not its freshness; still it renews itself even as does the moon.' The sensuality of the picture was recognized by his friend Swinburne, who wrote excitedly to Bell Scott, 'I daresay you have heard of his picture in oils of a stunner with flowers in her hair and marigolds behind it? She is more stunning than can be decently expressed.' The model was Fanny Cornforth, born Sarah Cox in Steyning, Sussex, in 1824. The painting was commissioned by Rossetti's friend George Price Boyce, whose predilection for attractive young models was notorious among his fellow painters. The likeness, which was remarked upon by William, may be compared with the portrait drawing executed in the same year (Fig. 27).

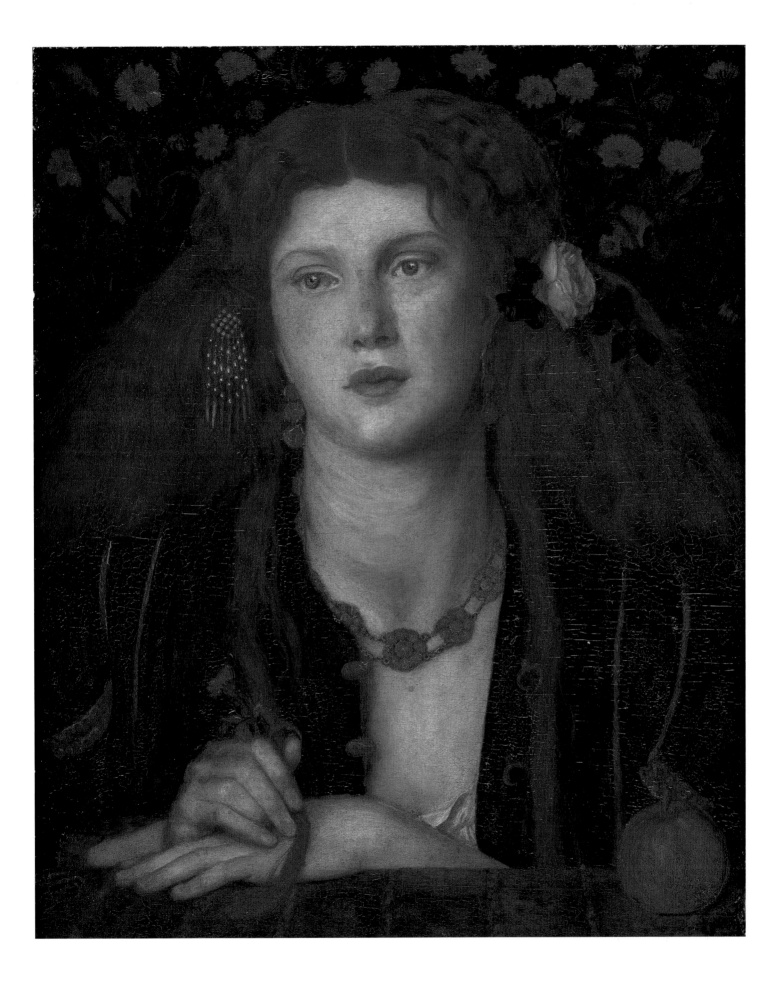

Dantis Amor

1860. Oil on panel, 74.9 x 81.3 cm. Tate Gallery, London

Fig. 28
Study for Dantis Amor
1859–60. Pen and ink
on paper, 25 x 24 cm.
Birmingham Museum
and Art Gallery

The oddity of this picture may be explained, in part, by the circumstances of its execution. It was painted on a cupboard door during the decoration of the Red House, which was designed for William Morris by Philip Webb in 1859. The decoration was begun in the summer of 1860 and *Dantis Amor* was the central panel of three, the others showing the earthly and heavenly salutations of Beatrice; all three were removed when the Morrises left the house in 1865.

Love stands in front of a diagonally divided sky with the head of Christ in the upper left, surrounded by formalized rays of the sun, and that of Beatrice in the lower right, within a moon set against a star-filled sky. Love is holding an unfinished sundial, which, as in the study (Fig. 28), would have shown the time to be nine o'clock, nine being the mystic number which Dante associated with Beatrice.

A comparison between the study and the painting reveals something of the emotional conflict which affected Rossetti at the time. The profile of Beatrice in the study is clearly that of Jane Morris, whereas in the painting her head is, diplomatically perhaps, that of Lizzie Siddal. The head of Christ, within a nimbus of rays, had previously appeared in the 1858 drawing of *Mary Magdalene at the Door of Simon the Pharisee* (Fig. 24), when it was said to have been a portrait of Burne-Jones.

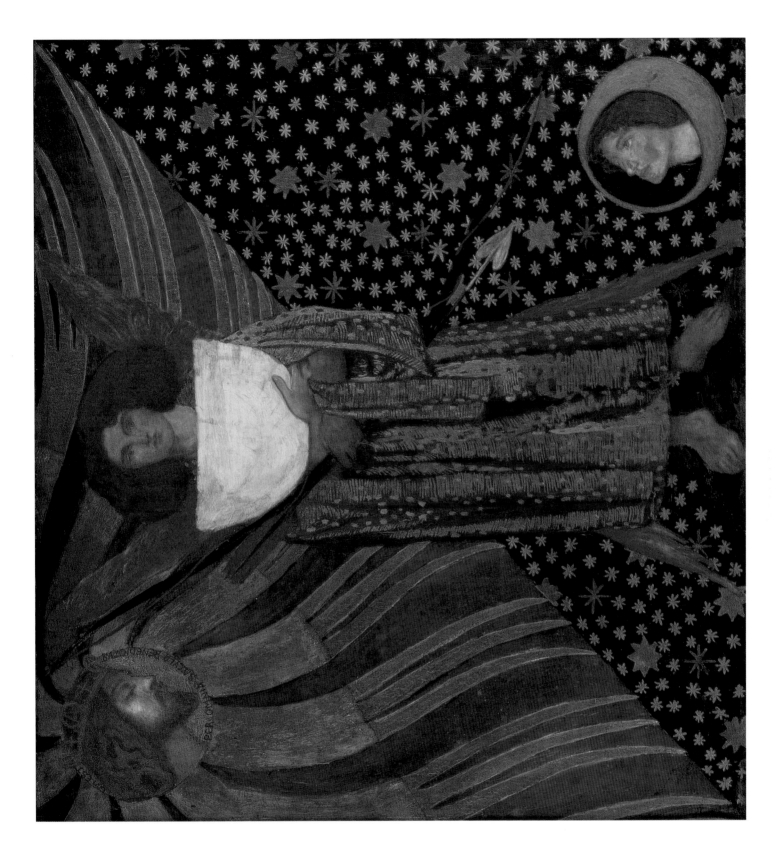

Fair Rosamund

1861. Oil on canvas, 52 x 42 cm. National Museum of Wales, Cardiff

This was the third of Rossetti's shoulder-length portraits posed for by Fanny Cornforth. She is shown standing behind a decorated window-sill in front of a bottle-glass screen, a property he also used to represent medieval windows in *St Catherine* (Plate 13) and *La Donna della Finestra* (Plate 47). She appears as the character of 'Fair Rosamund', the historical Rosamund Clifford, mistress of King Henry II. According to legend she was kept in a house, set in a maze, near Woodstock, Oxfordshire, where only he could find her by means of a red silken cord, which Rossetti shows attached to an elaborate peg. She was eventually traced there by Queen Eleanor, Henry's wife, who had her murdered.

Rossetti probably found the subject in Thomas Percy's *Reliques of Ancient English Poetry*, published in 1765, which was a favourite book of Morris and Burne-Jones. His fondness for subjects of incarcerated women was shared with many Victorian artists, including Burne-Jones. The reasons are complex, but certainly include chivalry, pathos and the perceived dependence of woman on man, which in turn was a reaction, in some cases unconscious, to women's growing demand for education, independence and emancipation.

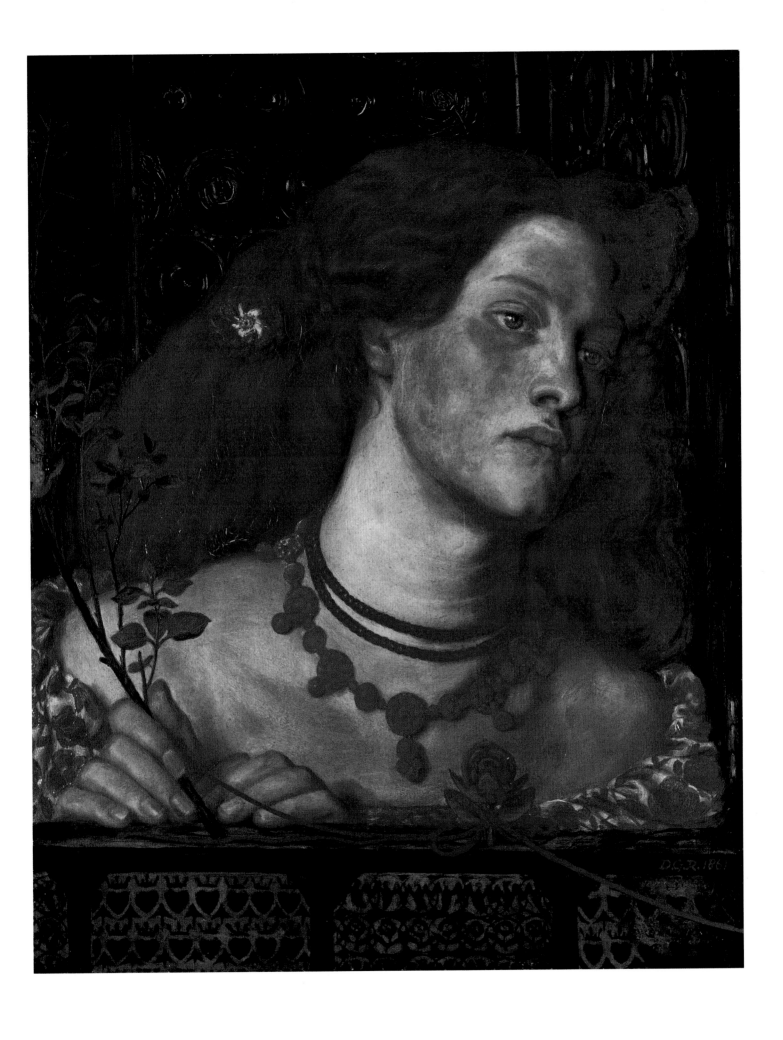

The Sermon on the Mount

1862. Stained glass. South nave window, All Saints, Selsley, Gloucestershire

72

All Saints, Selsley, was the first commission for stained glass received by Morris, Marshall, Faulkner and Company. The architect, G F Bodley was a friend of G E Street, to whose architectural practice Morris and Webb had been articled. Rossetti, who was initially enthusiastic about the Firm and almost certainly wrote the Company's immodest prospectus, provided about 30 designs between 1861 and 1864, but the work was not lucrative – he received £5 for this drawing – and he soon lost interest, claiming, 'Anything will do for stained glass.' It is also possible that his carelessness may have made Morris reluctant to use him as a designer. His first cartoon for *The Sermon on the Mount* was too large and he scribbled on the back, 'Dear Top, If you have to reduce it do it in pencil and then I'll draw it again. It strikes me now it's done there's no space left for the lead-lines is there?' Morris's craftsmen had to provide a reduced copy for Rossetti to redraw.

All the faces are individual portraits: George Meredith sat for Christ, William Morris for St Peter, Lizzie Siddal for Mary and Fanny Cornforth for Mary Magdalene; the head of Judas is that of the art dealer Ernest Gambart, with whom Rossetti had a volatile relationship. In 1869 his Aunt Charlotte Polidori commissioned a replica from the Firm and had it installed in Christchurch, Albany Street, London, in memory of her sister Margaret who had died in 1867.

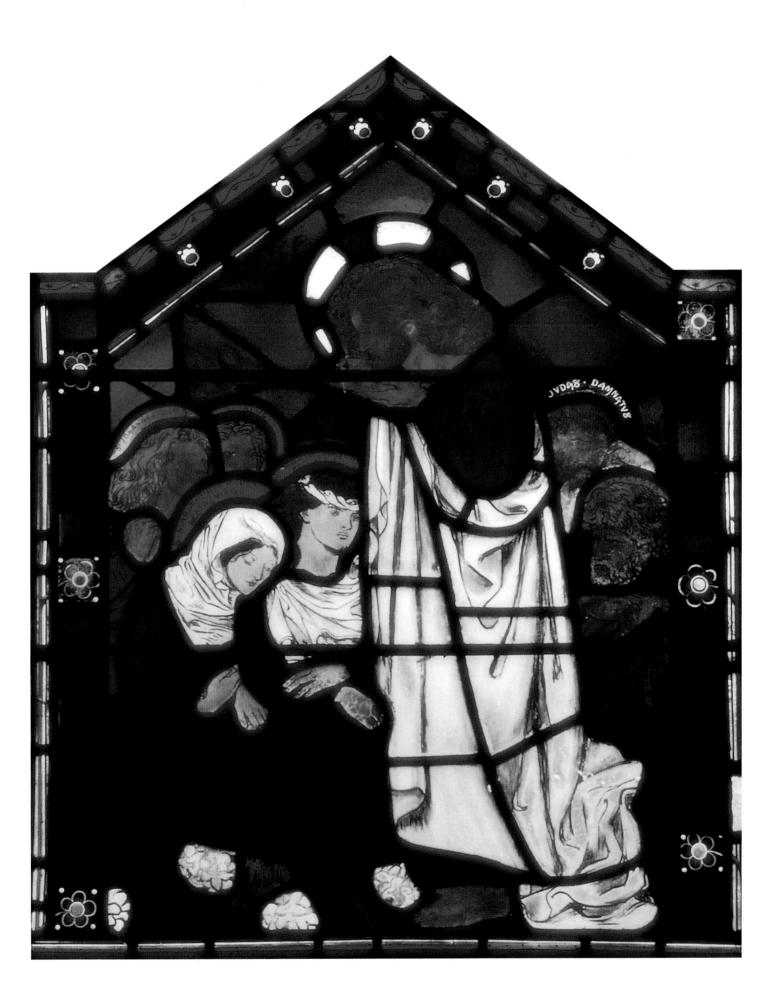

Portrait of Maria Leathart

1862. Oil on panel, 33 x 30 cm. Family collection

Fig. 29
FORD MADOX BROWN
Portrait of James
Leathart
1863–4. Oil on canvas,
34 x 28 cm.
Family collection

Rossetti travelled to Newcastle upon Tyne in December 1862 and stayed with William Bell Scott while painting this portrait of Maria, the 22-year-old wife of James Leathart. Leathart, who earned his living as a lead manufacturer, was the Secretary of the Government School of Design of which Bell Scott was the Master. Advised by Bell Scott, he built up a fine collection of Pre-Raphaelite paintings and had already purchased two Rossetti watercolours, *The Bower Garden* (Private collection) and *Paola and Francesca da Rimini* (Cecil Higgins Art Gallery, Bedford), and Brown's *Pretty Baa Lambs* (Birmingham Museum and Art Gallery) and commissioned a replica of *Work*, which was completed in 1863 and can be seen in Leathart's portrait (Fig. 29), commissioned from Brown in 1863 as a pendant to Rossetti's painting of his wife.

Rossetti completed the painting in London, borrowing Maria Leathart's dress to paint from. He began two versions of the picture but soon abandoned one of them as an unsatisfactory likeness. Unable to obtain the jasmine that he had hoped to include, he painted the blossoms at the left of the picture from artificial flowers. He had reservations about the accuracy of the portrait, writing to Leathart that, 'It may not improbably become more strikingly like as Mrs Leathart gets rather older.'

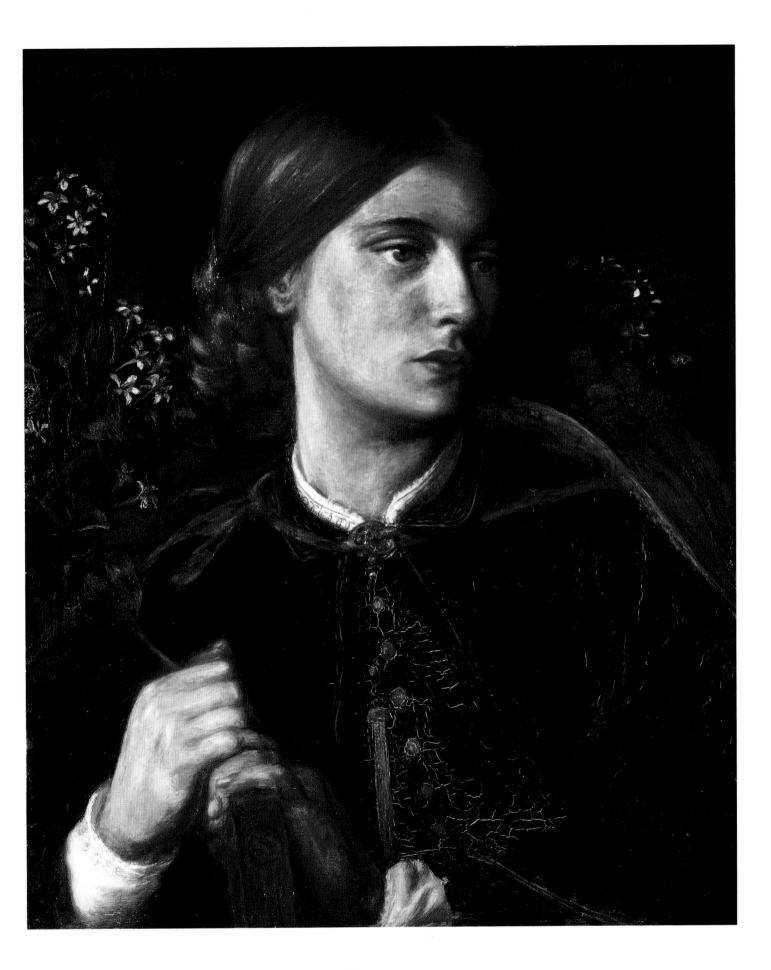

Girl at a Lattice

1862. Oil on canvas, 30.5 x 27 cm. Fitzwilliam Museum, University of Cambridge

Fig. 30
FORD MADOX BROWN
'Mauvais Sujet'
1863. Oil on canvas.
Size and location unknown

This charming and informal painting, a domestic version of his familiar shoulder-length portraits of women, was one of the first pictures he painted after Lizzie Siddal's death. The sitter was the Browns' young Irish maid at their house in Hampstead, where Rossetti stayed for a time, unable to face returning to Chatham Place after his wife's suicide. The rotten windowsill suggests that it was taken from a real window at the house, and the small, unpretentious jug and saucer, Staffordshire blue and white rather than the exotic Oriental china Rossetti later collected, was certainly Brown's, 'At [whose] table the standard of the common English Willow-pattern plate was boldly raised', according to Georgiana Burne-Jones. The slightly incongruous gold and coral necklace was Rossetti's own and appears in many of his pictures. A year later, as Teresa Newman and Ray Watkinson have pointed out in *Ford Madox Brown and the Pre-Raphaelite Circle* (1991), Brown painted the same girl in a similar composition to that used by Rossetti in *'Mauvais Sujet'* (Fig. 30), an unexpected and probably unconscious homage from master to pupil.

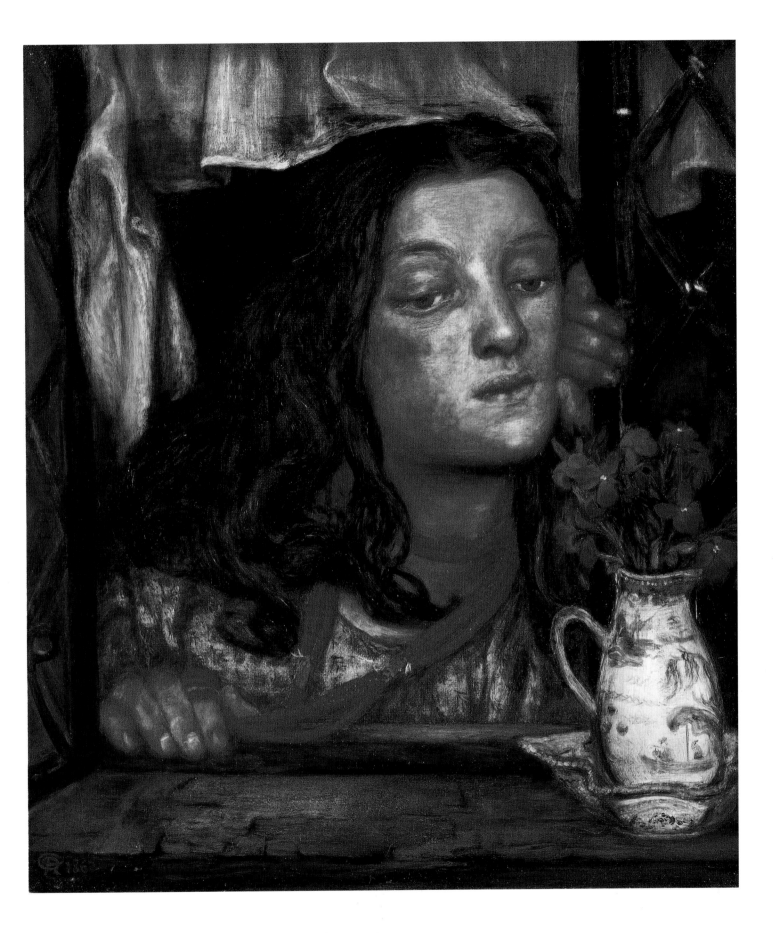

24 Helen of Troy

1863. Oil on panel, 31 x 27 cm. Hamburger Kunsthalle

78

In 1863 Rossetti painted *Helen of Troy* and *Joan of Arc* (Tate Gallery, London), both of which, particularly the latter, are subjects removed from his usual interests and therefore unexpected. It seems quite possible that he was inspired to do so by a series of embroideries of 'Good Women', loosely based on Chaucer's poem of the same name, which included both Joan and Helen. They were conceived by Morris and Burne-Jones in 1860 as part of the decorative scheme for Morris's home, the Red House, and executed by Jane and her sister Bessie. The embroideries depict full-length figures whereas Rossetti's paintings are only shoulder length, but the series must have been discussed among the friends and may have provided him with subjects. Helen, 'Destroyer of ships, destroyer of men, destroyer of cities', as Rossetti, quoting from the Greek playwright Aeschylus, inscribed on the back of the picture, was posed for by Fanny Cornforth. Before painting the picture Rossetti had written to his mother, asking to borrow any stereoscopic photographs of cities or ships from which to paint the background, a blazing fleet, in the event he appears to have used his imagination.

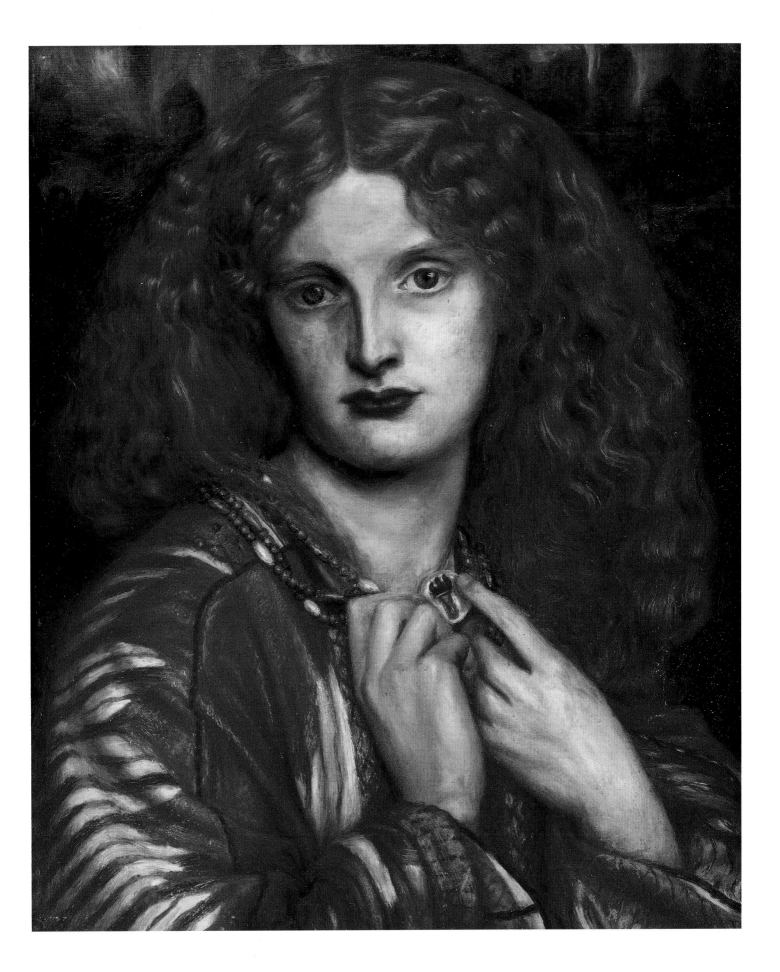

How Sir Galahad, Sir Bors and Sir Percival were Fed with the Sanc Grael; but Sir Percival's Sister Died by the Way

1864. Watercolour on paper, 29.2 x 41.9 cm. Tate Gallery, London

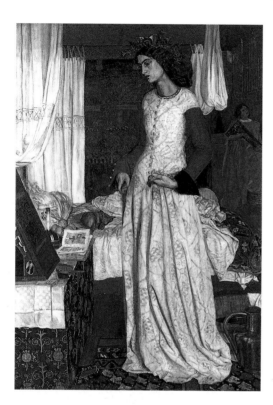

Fig. 31
WILLIAM MORRIS
La Belle Iseult
1858. Oil on canvas,
71.7 x 50 cm.
Tate Gallery, London

Commissioned by Ellen Heaton, this watercolour is a replica, with minor variations, of a finished study for a design for the Oxford Union murals of 1857 that was not carried out. The scene depicted, from Malory, shows the pilgrims receiving the Eucharist in the Holy vessel from an angel who stands behind a miraculous lily. Behind them stands a row of red-winged angels and to the left is the Holy Spirit, which Malory associates with the appearance of the Sanc Grael, in the form of a dove carrying a golden censer in its beak.

It was during the disastrous painting of the Oxford Union frescos that Morris and Rossetti met Jane Burden, who came to pose for them in their lodgings at 13 George Street. On Rossetti's departure in November she continued to sit for Morris for *La Belle Iseult* (Fig. 31), his only surviving completed oil painting. According to Val Prinsep, a member of Rossetti's team of muralists, Morris read Charles Dickens's *Barnaby Rudge* to her when she was not sitting, which Prinsep thought a most unromantic form of courtship.

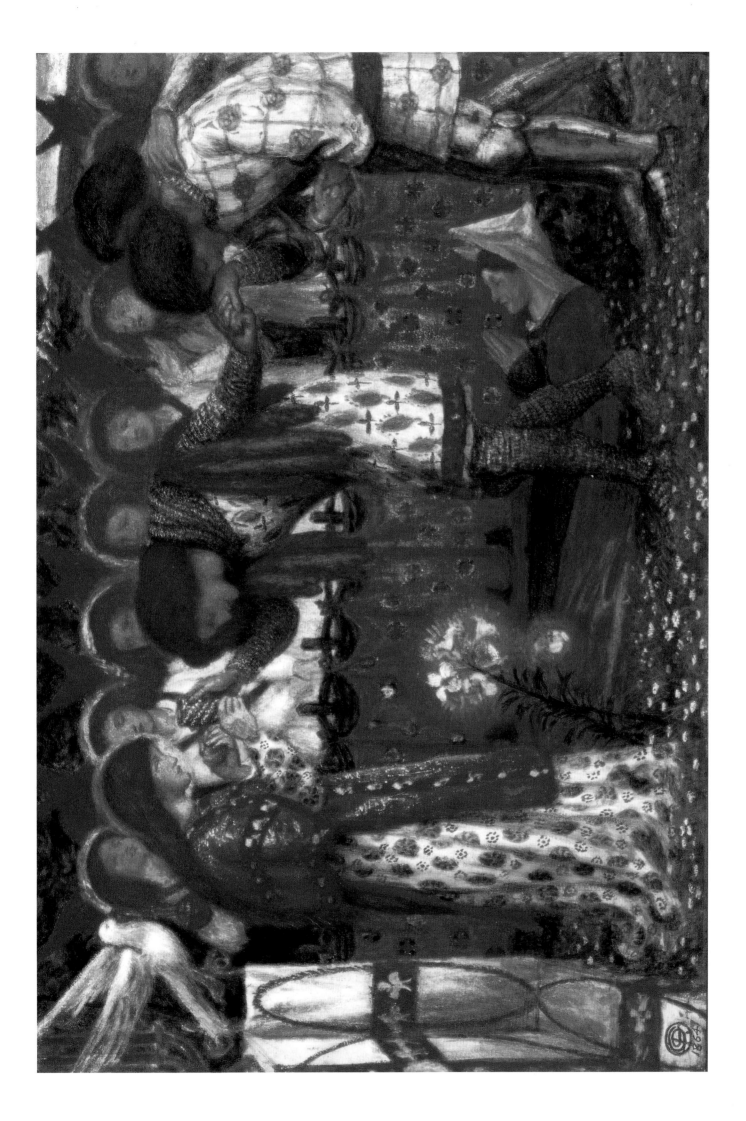

Beata Beatrix

1864–70. Oil on canvas, 86 x 66 cm. Tate Gallery, London

Beata Beatrix, a portrait of Rossetti's dead wife, Elizabeth Siddal, is among the most haunting of his images and he grew to regard it as her memorial. According to a letter from Rossetti to Ellen Heaton, it was begun 'many years' before her death in 1862, but was not seriously worked on until 1864. Once again the subject comes from Dante's *Vita nuova*, and shows the mystical translation of Beatrice from earth to heaven. On the right, in the desolate Florentine streets, with the Ponte Vecchio and the Duomo in the distance, stands Dante, staring across to the Angel of Love at the left of the picture. Beatrice sits, as in a trance, beside a sundial on which the shadow falls on nine, the hour of her death on 9 June 1290. A red, haloed bird, the messenger of death, drops a poppy, the symbol of sleep, into her folded hands.

Rossetti painted at least five replicas of this painting, such was the popularity of the subject among his patrons. According to Dunn, quoted by Virginia Surtees in her *catalogue raisonné*, the original unfinished painting, from which *Beata Beatrix* was worked up, was rescued from oblivion by Charles Augustus Howell, an Anglo-Portuguese adventurer, whose utter amorality and compulsive lying both amused and exasperated Rossetti who, nevertheless, employed him in various capacities throughout his life, including the disinterment of his poems.

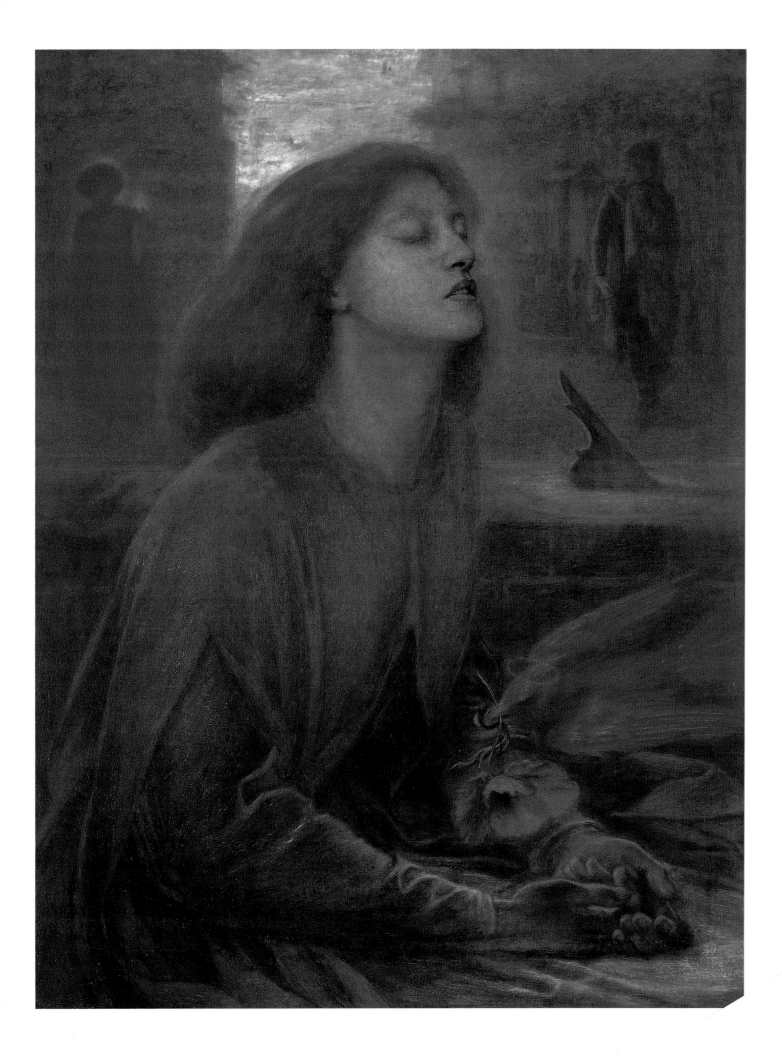

Venus Verticordia

1864–8. Oil on canvas, 98 x 70 cm. Russell Cotes Art Gallery and Museum, Bournemouth

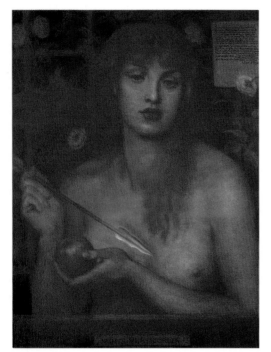

Fig. 32
Study for Venus
Verticordia
*c*1863. Chalk on paper,
77.5 x 62 cm.
Faringdon Collection
Trust, Buscot Park,
Oxfordshire

Rossetti probably began work on the chalk study (Fig. 32) in 1863, using as his model a cook who, according to William, was almost six feet tall. In the study a bird perches behind Venus on a rose trellis, which bears a striking resemblance to the 'Trellis' wallpaper designed by Morris and Webb and manufactured in the same year. A tablet in the bottom centre bears the painting's title, a device used by Rossetti on a number of occasions, which may be derived from the practice of the Venetian painter Giovanni Bellini (*c*1430–1516), who signed his work on similar plaques. At the right hangs a scroll on which Rossetti's sonnet of the same title is inscribed. In the finished painting, completed for John Mitchell of Bradford in 1868, the sill and trellis have been replaced by honeysuckle and roses; butterflies surround the goddess's halo and alight on her arrow, Cupid's dart, and on her apple that, according to myth, was awarded to her by Paris for her beauty. The cook's head has been replaced by that of Alexa Wilding. *Venus Verticordia*, 'Changer of the Heart', is one of only two semi-nude female figures in Rossetti's completed paintings, and it may well have been the nudity, rather than the flowers, which he described as 'coarse', that really offended John Ruskin.

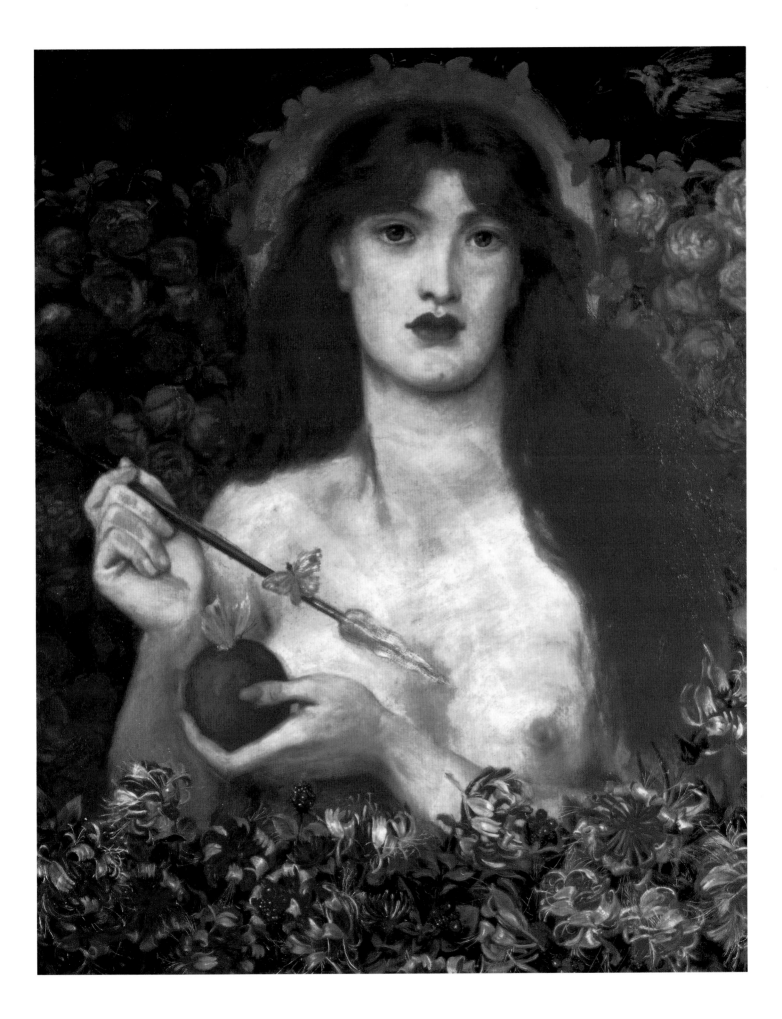

28 The Blue Bower

1865. Oil on canvas, 90 x 69 cm. Barber Institute of Fine Arts, University of Birmingham

The Blue Bower is Rossetti's last major portrait of Fanny Cornforth, who is already exhibiting the signs of plumpness that caused Rossetti to nickname her the 'Good Elephant' in later years. The colour is astonishingly intense, her brilliant-green, fur-lined jacket making a dramatic contrast with the hexagonal blue and white tiles against which she is posed. Purple and white passion flowers crawl across the tiles, which reflect his interest in Oriental blue and white porcelain, a taste he indulged after his move to Cheyne Walk in 1862 and shared with his near neighbour James McNeill Whistler. Both bought ceramics from the dealer Murray Marks who was later a valuable patron. The painting must have been completed during a period when Rossetti was short of 'tin', for he sold it to the dealer Ernest Gambart for £210. Gambart sold it, almost immediately, to his fellow dealer Agnew at a profit of £340.

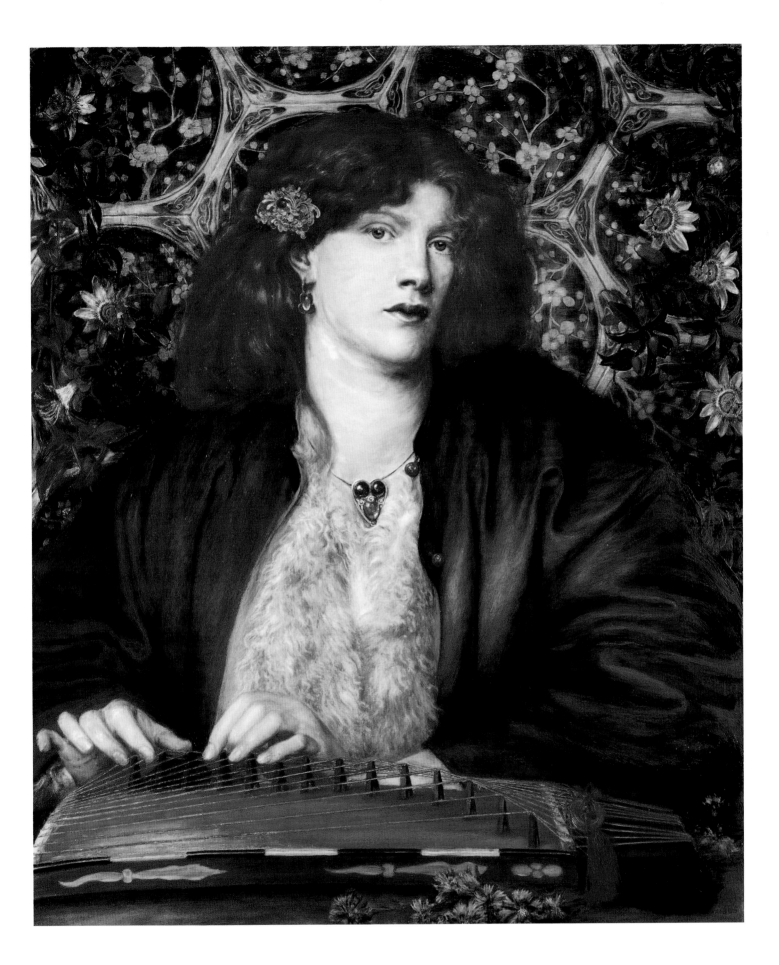

The Beloved

1865–6. Oil on canvas, 82.5 x 76.2 cm. Tate Gallery, London

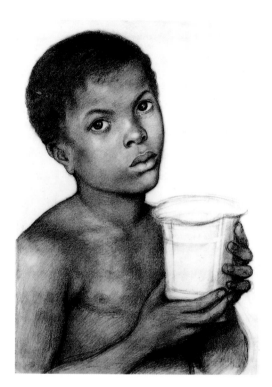

Fig. 33
Study of the Black
Boy for The Beloved
1864–5. Chalk and pencil
on paper, 50 x 36 cm.
Birmingham Museum and
Art Gallery

The Beloved, also called 'The Bride', is Rossetti's most complex and spatially unconvincing multiple portrait. It was originally conceived as a 'Beatrice' for Ellen Heaton in 1863, however, the golden hair and, as Rossetti described it, 'bright' complexion of the model, Marie Ford, led him to change his mind. The subject is taken from the Old Testament 'The Song of Solomon' and illustrates the lines, 'She shall be brought unto the King in raiment of needle-work; the virgins that be her fellows shall bear her company.' The 'raiment of needle-work' was provided by George Price Boyce, who lent Rossetti a prized Japanese silk dress.

The little black page (Fig. 33), a frequent attendant in English seventeenth-century paintings but rare in the nineteenth century, was substituted at an early stage for a mulatto girl. Boyce entered in his diary that Rossetti, 'First saw [him] at the door of an hotel … whilst sitting the tears would run down his cheeks … when not sitting he was accustomed to be most active, running and jumping etc.'

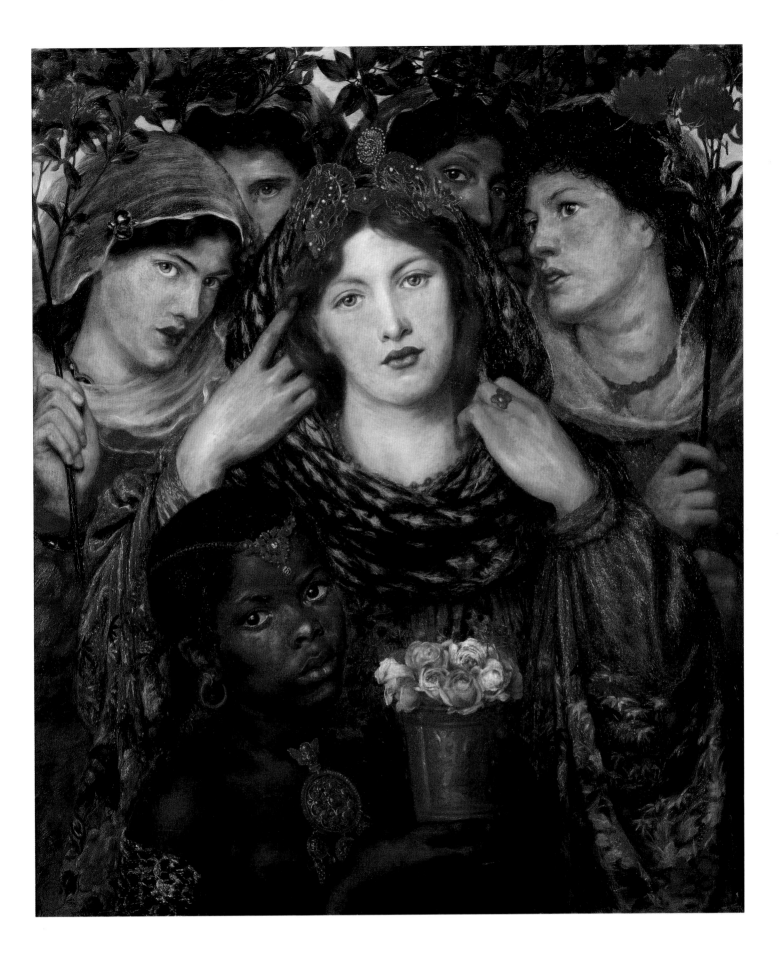

1866. Oil on canvas, 89 x 86 cm. Tate Gallery, London

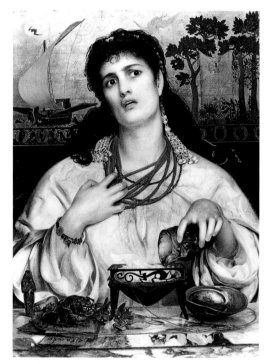

Fig. 34
FREDERICK SANDYS
Medea
1868. Oil on panel,
62 x 46 cm.
Birmingham Museum
and Art Gallery

The most sumptuous of Rossetti's portraits, *Monna Vanna*, or 'Belcolore' as he retitled it in 1873, is clearly based on sixteenth-century Venetian prototypes of Mary Magdalenes and Venuses, and Rossetti himself described it as Venetian, the original title being 'Venus Veneta'. It was painted from Alexa Wilding whose much remarked upon vacuity is, unintentionally, quite evident. She appears as a bored society beauty, resplendent in golden brocade, playing idly with her coral necklace and holding, but barely using, a feathered fan. The coiled ammonite-shaped hair ornaments had probably been acquired by Rossetti only recently, for this is their first appearance in his work; his fondness for them is evident as they appear in at least six further paintings. The necklace, an equally prized property, was also used by Frederick Sandys (1829–1904) in his striking painting, *Medea* (Fig. 34), painted while sharing Rossetti's studio at Cheyne Walk. The two men had first met in 1857 when Rossetti sat for his portrait drawing by Sandys for inclusion in the engraving *A Nightmare*, an attack on Ruskin and a wicked parody of Millais's *Sir Isumbras at the Ford* (both in the Lady Lever Art Gallery, Port Sunlight), and they had remained friends. However, after Sandys had ceased working in his studio, Rossetti accused him, justifiably, of plagiarism, which led to a break in their friendship.

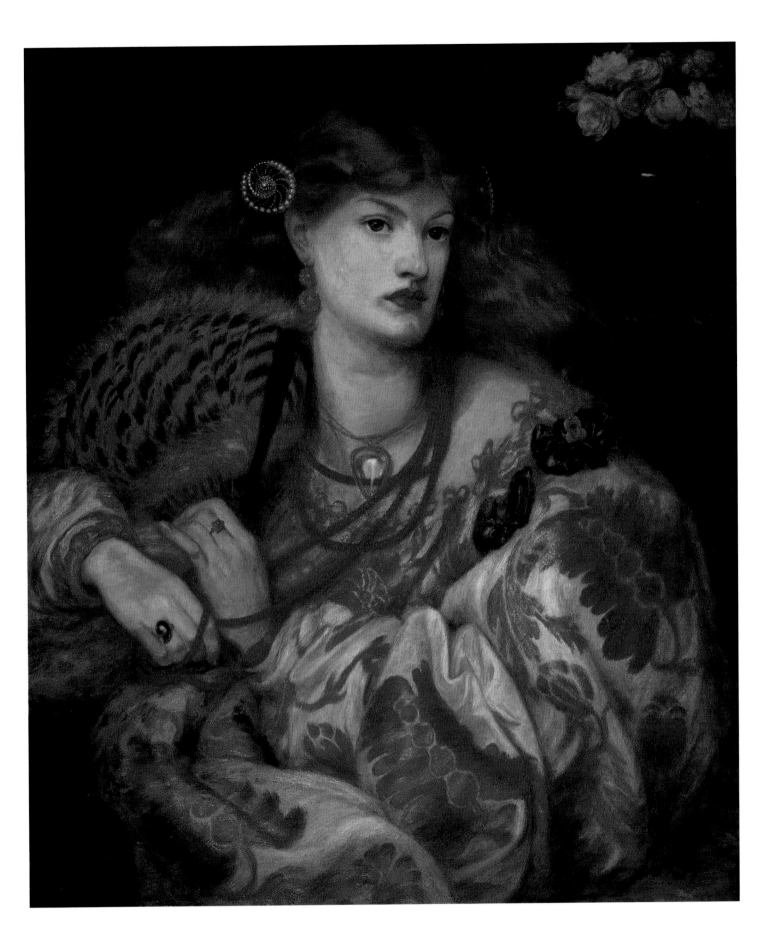

31 Regina Cordium

1866. Oil on canvas, 59.7 x 49.5 cm. Art Gallery and Museum, Kelvingrove, Glasgow

92

Rossetti had used the same title, which means 'Queen of Hearts', for two earlier but otherwise unconnected works, a portrait of Lizzie Siddal in 1860 (Johannesburg Art Gallery) and a portrait of Mrs Aldam Heaton, commissioned by her husband in 1861 (Private collection); he now applied it to Alexa Wilding. The theme is emphasized by the heart-shaped locket with Cupid's crossed arrows suspended from the chain about her neck, and the plaque of Blind Cupid, symbolic of both the blindness of love and the darkness of carnal desire, hanging in the top right corner of the picture. Roses, symbols of love and beauty, appear before the incongruous lace-covered sill which bears the title. She is posed against a background with a design of espaliered cherry trees, possibly a further variant of one of Rossetti's unfulfiled wallpaper designs.

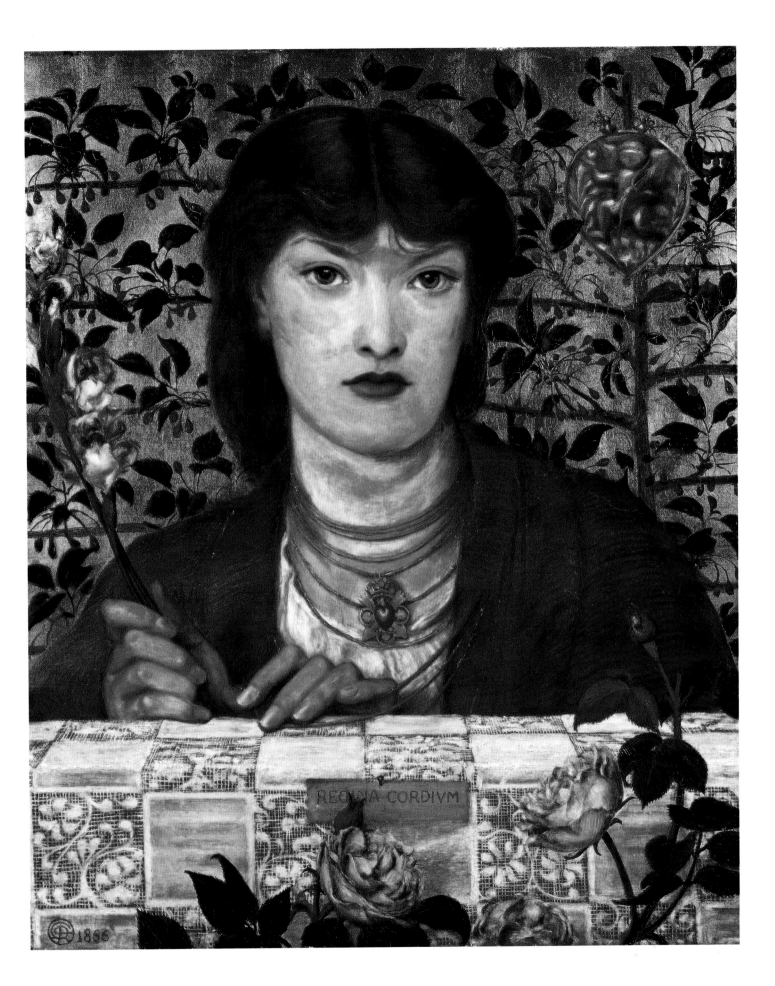

1866–70. Oil on canvas, 94 x 82.5 cm. Lady Lever Art Gallery, Port Sunlight

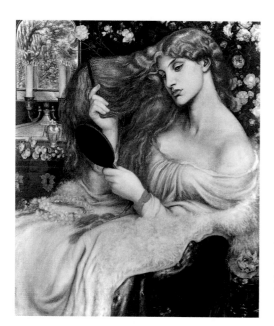

Fig. 35
Lady Lilith
1864–8. Oil on canvas,
95 x 81 cm.
Samuel and Mary R
Bancroft Memorial,
Delaware Art Museum,
Wilmington, DE

Some time during the painting of this picture Rossetti conceived the idea of contrasting it with a picture of *Lady Lilith* (Fig. 35), the legendary first wife of Adam and a personification of lust in Jewish folklore, that he had begun in 1864 from Fanny Cornforth. *Sibylla Palmifera* was to represent 'Soul's Beauty', the title of a sonnet he wrote to accompany the painting, in contrast to the 'Body's Beauty' symbolized by *Lady Lilith* and also the subject of a sonnet. Whereas the modestly dressed sibyl sits in a temple surrounded by the emblems of Love, Death and Mystery, the Cupid, the skull and the sphinx, Lilith, fetchingly décolleté, admires herself in a mirror, the attribute of vanity. Her candles, to the left, illuminate a further mirror, in stark and worldly contrast to the sibyl's votive flame, burning before the Cupid and roses of Love. The initial contrast between the pictures, posed for by the sensuous Fanny Cornforth and the demure Alexa Wilding respectively, was very marked, but in 1872–3 Rossetti replaced Fanny's head with a further one of Alexa at the request of its buyer, Frederick Leyland, largely destroying his original concept.

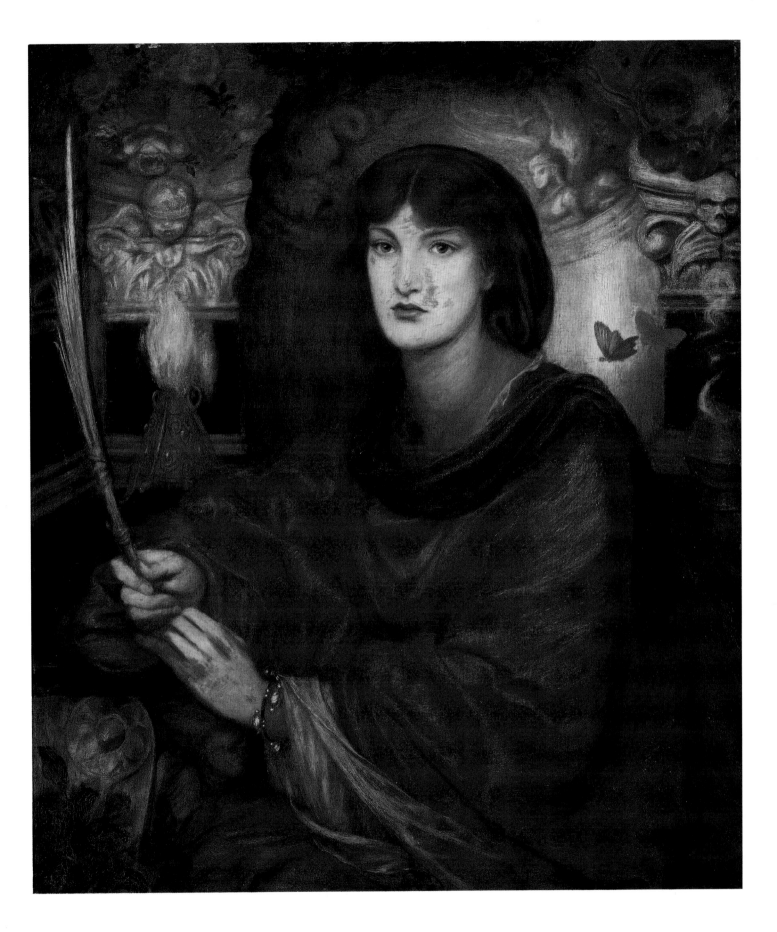

1868. Chalk on paper, 84 x 71 cm. Ashmolean Museum, Oxford

Fig. 36
JOHN PARSONS
Jane Morris
1865. Photograph.
Victoria and Albert
Museum, London

Reverie is one of the first of many subsequent portraits of Jane Morris, Rossetti's final muse. The Morrises returned to London from Bexleyheath in 1865 and their new proximity allowed greater intimacy with Rossetti. Jane sat for a series of photographs taken by John Parsons in July, in poses arranged by Rossetti, and *Reverie* is clearly based on the photograph shown (Fig. 36). Rossetti probably used the photographs when he sketched in the outline and as an *aide-mémoire* in Jane's absence, but he would normally have worked from live sittings in addition to the photograph. Jane's dark and striking features, heavy lips and full hair, which Rossetti was to immortalize, created a new prototype for the 'Pre-Raphaelite' woman that superseded that of Lizzie Siddal, who had been the dominant golden-haired model of the early P R B years. The Morrises were pioneers of the Rational Dress movement and Jane eschewed corsets and crinolines. Her appearance startled the American novelist Henry James when he called on them in Queen Square, he wrote:

> Imagine a tall lean woman in a long dress of some dead purple stuff, guiltless of hoops (or of anything else I should say), with a mass of crisp black hair, heaped into great wavy projections on each of her temples, a thin pale face, great thick black oblique brows, joined in the middle and tucking themselves away under her hair, a mouth like the 'Oriana' in our illustrated Tennyson, a long neck, without any collar, and in lieu thereof some dozen strings of outlandish beads.

Jane's appearance was to be caricatured in *Punch* as the 'Aesthetic' hostess 'Mrs Cimabue Brown', a creation of George Du Maurier (1834–96) who first met her in 1870, and who was no admirer.

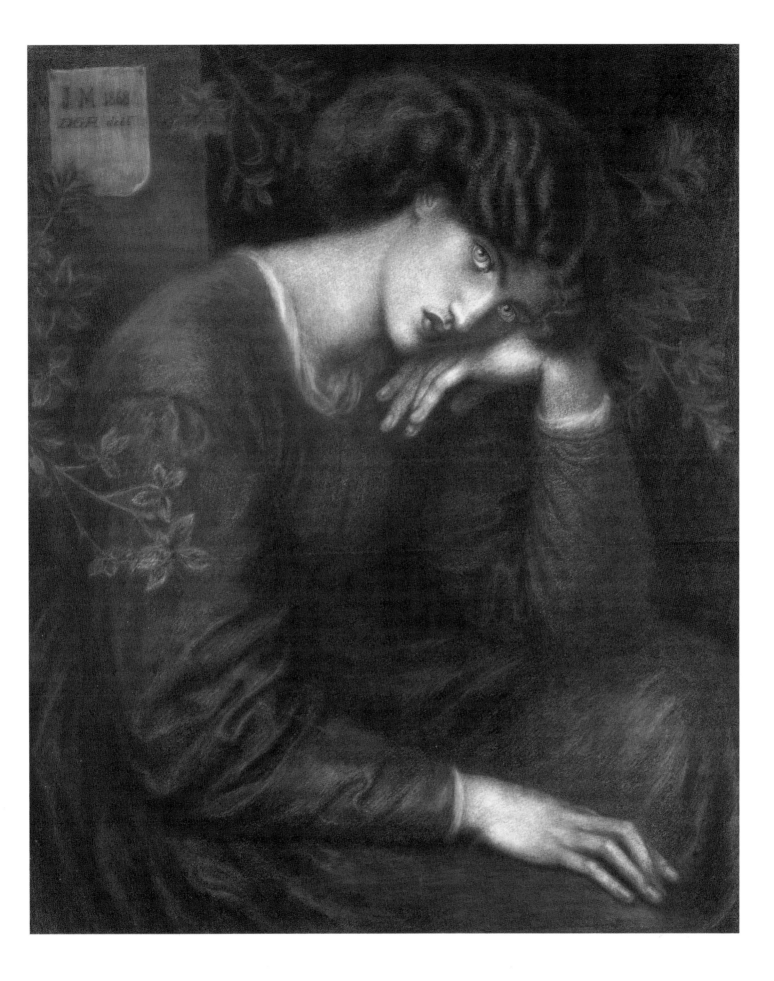

La Pia de' Tolomei

*c*1868–80. Oil on canvas, 105.8 x 120.6 cm. Spencer Museum of Art, University of Kansas, Lawrence, KS

The subject is taken from the final lines of Canto V of the *Purgatorio*, in which Dante describes his meeting with La Pia. She had been imprisoned in a fortress in the Maremma, a marshy region on the Tuscan coast, and eventually killed, deliberately or through neglect, by her husband, Nello della Pietra. The subject would probably have been known to Rossetti's public through 'Maremma', a poem by Felicia Hemans whose verse was extremely popular.

La Pia sits on the ramparts of the fortress framed against ivy, representative of 'clinging memory', toying with her wedding ring, once a joy and now a mockery. In the foreground a sundial symbolizes the passing of time and beside it her rosary rests on a breviary, beneath which can be seen old love letters from her husband; clearly the message is that fulfilment has been replaced by forced celibacy. The picture was completed in 1880, when Rossetti's assistant Charles Fairfax Murray provided sketches of the Maremma swamps and Frederick Shields lent photographs of ivy-covered walls. It had a personal significance for both artist and sitter, the latter married to a man she did not love. In Rossetti's caricature, *The M's at Ems* (Fig. 37), sent to Jane in 1869 during her stay with Morris at the German spa town of Bad Ems, her pose is a deliberate echo of *La Pia de' Tolomei*, a somewhat bitter joke, exclusive to the lovers.

Fig. 37
The M's at Ems
1869. Pen and ink on
paper, 11 x 18 cm.
British Museum, London

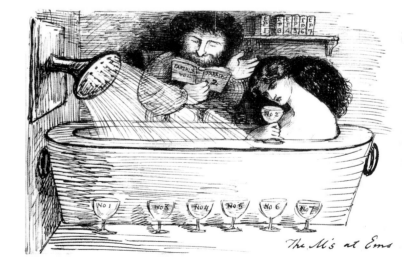

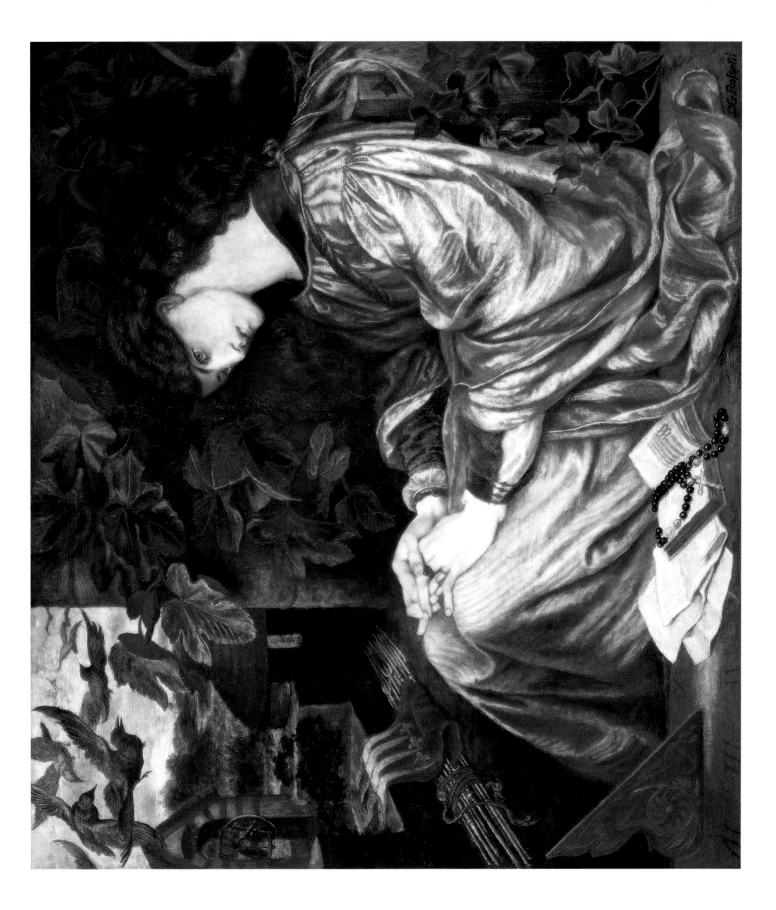

Study for Pandora

1869. Chalk on paper, 100.5 x 72.5 cm. Faringdon Collection Trust, Buscot Park, Oxfordshire

In Greek myth Pandora was the first woman created, fashioned from clay by the god Vulcan. As a punishment to man for the theft of fire by Prometheus, Pandora was given a box containing all the evils that would beset the world. As Jupiter intended, she released the contents of the box, with the exception of hope which remained within. In the finished oil (in Harvard University's Fogg Museum of Art) Rossetti has inscribed her casket with the motto 'Ultima manet spes' (Hope remains at last). The early Church drew a parallel between the myth of Pandora and the Fall of Man, and she was therefore seen as a pagan Eve. The face is taken from Jane Morris and the hands are also hers. Morris made great play on their length and languor in his poem, 'In Praise of my Lady', published in 1858. Jane's hands also seem to have had a profound effect on Rossetti, in whose paintings they become increasingly elongated and mannered, and they influenced his treatment of hands in general in his later pictures, such as *La Ghirlandata* (Plate 41). The evil spirits are shown as winged faces in the smoky nimbus which emanates from the casket and wreathes her head. In 1875 Swinburne described the picture as, 'among his mightiest in its Godlike terror and Imperial trouble of Beauty'.

> What of the end? These beat their wings at will,
> The ill-born things, the good things turned to ill,
> Powers of the impassioned hours prohibited.
> Aye, clench the casket now! Whither they go
> Thou mayst not dare to think: nor canst thou know
> If Hope still pent there be alive or dead.

(From 'Pandora', Dante Gabriel Rossetti)

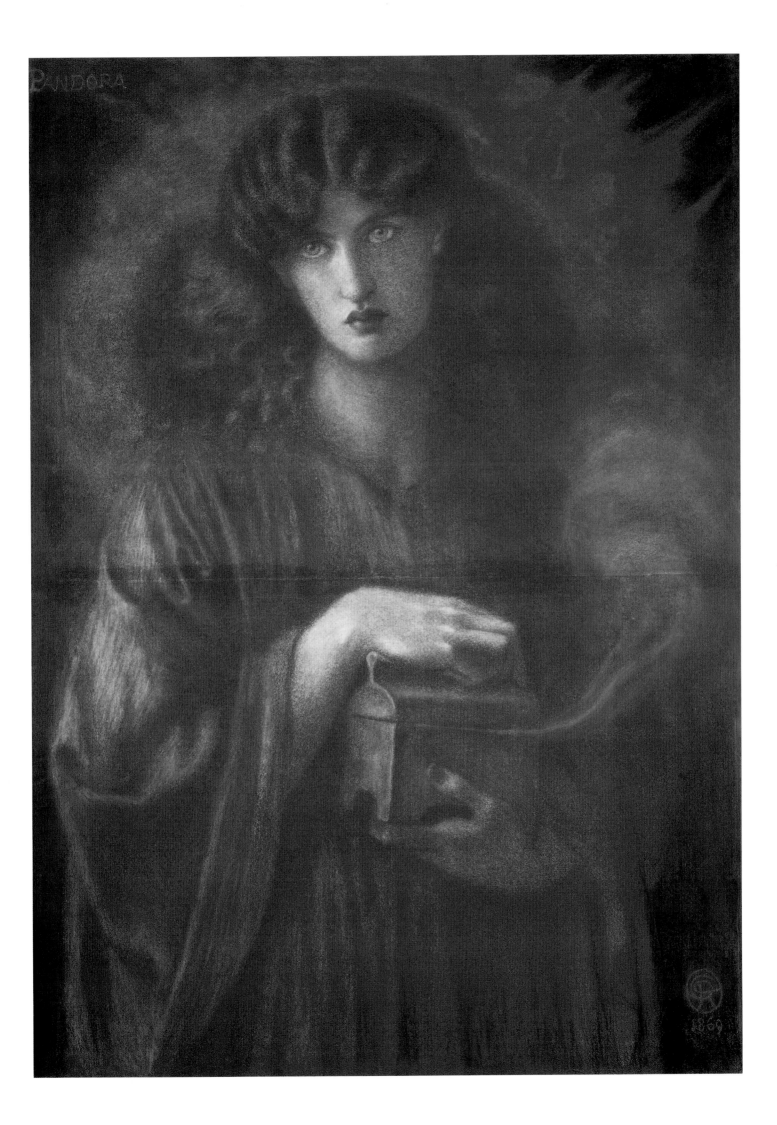

36 Mariana

1870. Oil on canvas, 109 x 89 cm. Aberdeen Art Gallery

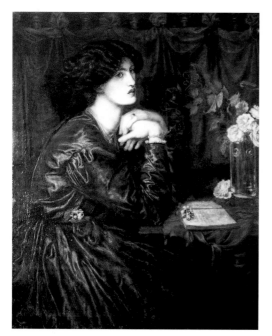

Fig. 38
Portrait of Mrs William
Morris in a Blue
Silk Dress
1868. Oil on canvas,
110.5 x 90 cm.
Society of Antiquaries,
Kelmscott Manor,
Gloucestershire

The subject is taken from the opening of Act IV of *Measure for Measure* by William Shakespeare. Mariana, suffering from rejection by her lover, Angelo, is engrossed by the boy's song, 'Take, O take, those lips away', which Rossetti inscribed on the frame. She has paused in her needlework, a craft, incidentally, at which Jane Morris excelled, and she wears in her hair the jewel first used in *Monna Vanna* (Plate 30). By 1868 the story of Mariana as told by Shakespeare, in which, in order to regain her lover, she impersonates Isabella, a religious novice who Angelo wishes to seduce, had been distorted by Tennyson in two very popular poems, 'Mariana' and 'Mariana in the South', which portray her as incarcerated in a moated grange waiting hopelessly for her lover's return. Rossetti had illustrated 'Mariana in the South' for Moxon's edition, and it is possible that he saw Mariana's story as obliquely related to that of *La Pia de' Tolomei* (Plate 34). The painting is closely related to his 1868 portrait of Jane Morris (Fig. 38) and, indeed, studies for *Mariana* were commenced in that year. The page was posed for by Willie Graham, the son of William Graham who commissioned the picture.

Lo! It is done. Above the enthroning throat
 The mouth's mould testifies of voice and kiss,
The shadowed eyes remember and foresee.
 Her face is made her shrine. Let all men note
That in all years (O love thy gift is this!)
 That they would look on her must come to me.

(From 'The Portrait', Dante Gabriel Rossetti)

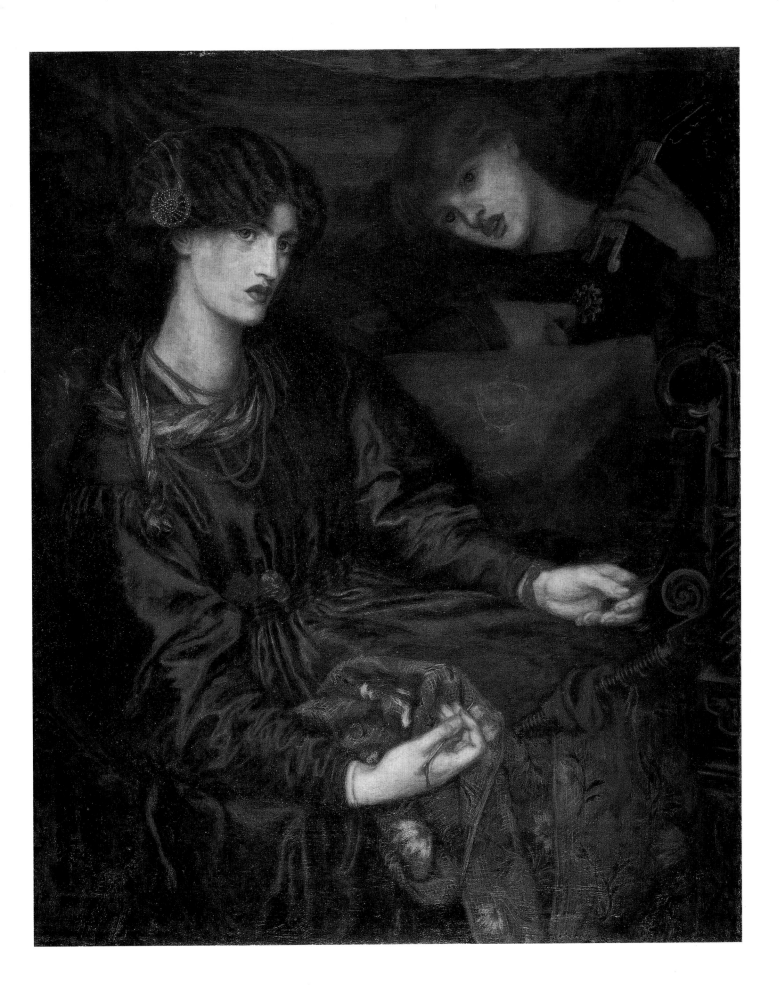

La Donna della Fiamma

1870. Chalk on paper, 100.5 x 75 cm. City Art Galleries, Manchester

The title, translated literally, means 'The Lady of the Flame', a subject inspired by the following lines in Dante's *Vita nuova*:

> Whatever her sweet eyes are turned upon,
> Spirits of Love do issue thence in Flame,
> Which through their eyes who then may look on them
> Pierce to the Heart's deep chamber every one.

The winged figure of Love within the flame is possibly adopted from the fiery spirits and angels of William Blake. In 1847, with £10 borrowed from his patient brother William, Rossetti had purchased a notebook of Blake's from William Palmer, the brother of Blake's disciple Samuel Palmer, and in the early 1860s he had helped to edit Alexander Gilchrist's life of the artist. Rossetti had a profound knowledge of Blake's work in art and literature and he would have been an obvious source for sprites.

Alastair Grieve has suggested convincingly in the Tate Gallery catalogue, *The Pre-Raphaelites* (1984), that Rossetti's frequent use of chalks after 1868 could be partly accounted for by his failing eyesight, which may have made working in the more delicate medium of watercolour difficult.

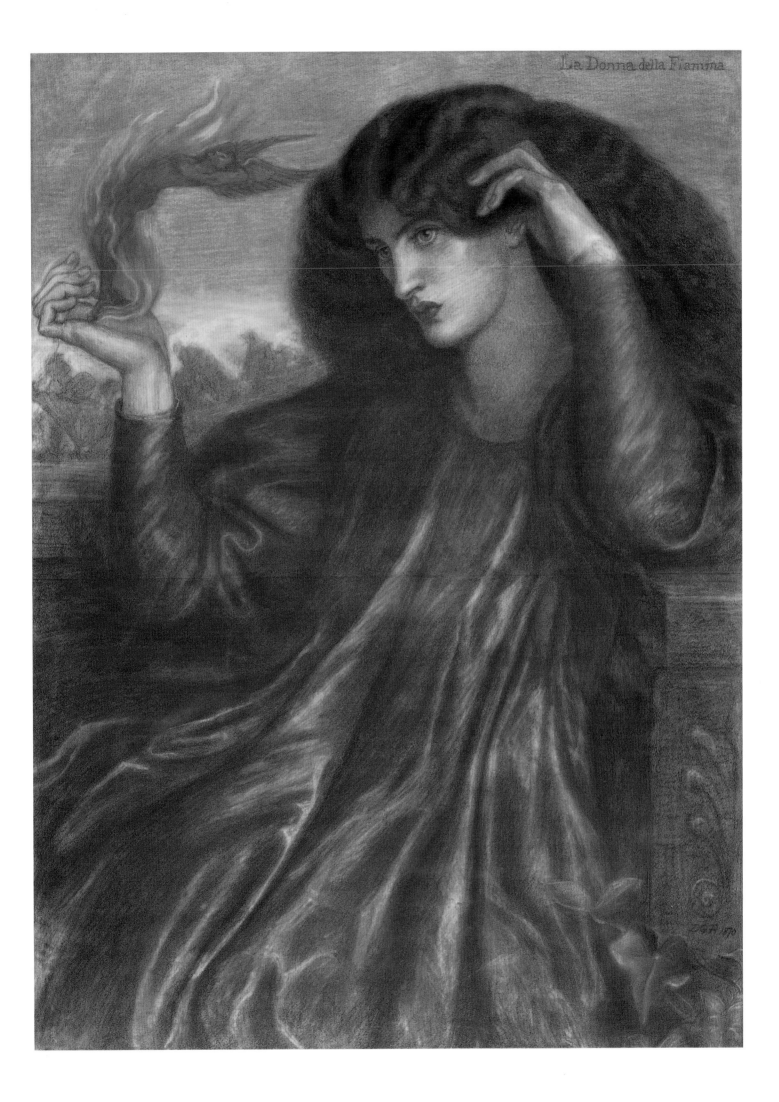

Water Willow

1871. Oil on canvas, 33 x 26.7 cm. Samuel and Mary R Bancroft Memorial, Delaware Art Museum, Wilmington, DE

Fig. 39
CHARLES
MARCH GERE
View of the East Front
of Kelmscott Manor
1892. Woodcut
(by W H Hooper).
Frontispiece to *News from Nowhere* (London, 1892)

This small and personal picture of Jane Morris was painted at Kelmscott Manor, near Lechlade in Gloucestershire, in 1871, during Morris's absence in Iceland, at the height of her love affair with Rossetti. The artist retained the painting until 1877 when he was financially straitened and in poor health. Jane is posed before Kelmscott Manor, the Thames-side Elizabethan house on which Morris and Rossetti had taken a joint lease earlier in the year. She looks at the artist wistfully, holding willow branches, a symbol of melancholy. Rossetti must surely have been inspired, consciously or not, by Shakespeare's song from *Othello*, as he and Jane were accustomed to reading Shakespeare aloud in the evenings:

> The fresh streams ran by her, and murmur'd her moans;
>> Sing willow, willow, willow:
> Her salt tears fell from her, and soften'd the stones;
>> Sing Willow, willow, willow:
> Sing all a green willow must be my garland.

Morris, who successfully manoeuvred Rossetti's removal from Kelmscott in 1874, loved the house passionately, and it is the final destination of his pilgrimage in *News from Nowhere* (see Fig. 39), the socialist Utopian novel that he published in instalments in the journal of the Socialist League, *Commonweal*, in 1889 and 1890. When he moved to The Retreat, a house on Upper Mall, Hammersmith, in 1878, he promptly renamed it Kelmscott House and derived great pleasure from the link between his two homes provided by the River Thames.

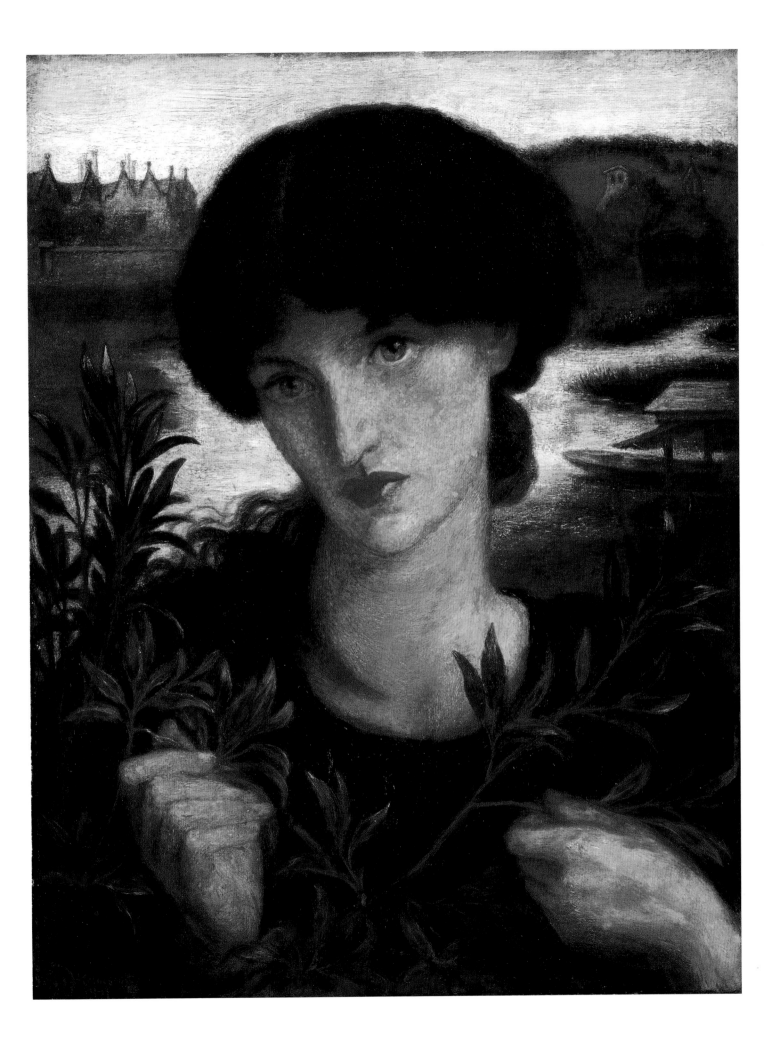

Dante's Dream at the Time of the Death of Beatrice

1871. Oil on canvas, 211 x 317.5 cm. Walker Art Gallery, Liverpool

This, the largest of Rossetti's paintings, is a virtual replica of a water-colour of 1856 owned by Ellen Heaton (Tate Gallery, London). The subject, an incident in the *Vita nuova* in which Dante dreams of being led by Love to see the dead Beatrice on her bier, had fascinated him since 1848. In September 1863 he asked Ellen to lend him his original picture from which to paint an oil version 'on a considerable scale'; he was able to make preliminary studies from it before its removal in April 1864 by Ruskin, who feared that Rossetti, seldom able to resist tampering with past works, might seek to improve it. In April 1869 William Graham agreed to commission the picture for £1,575, but stipulated that it should measure no more than 3 ft 6 in by 6 ft, which Rossetti characteristically ignored. On its completion in 1871 Graham refused the painting on the reasonable grounds that he had nowhere large enough to hang it. In 1873 it was purchased by L R Valpy, but returned to Rossetti in 1878 as Valpy was retiring to a smaller house near Bath. The picture was finally purchased in 1881 by the Corporation of Liverpool from the Liverpool Academy exhibition. The negotiations for its purchase were carried out by Hall Caine, with great diplomacy. A condition of the Corporation's purchasing policy was that only pictures exhibited in the annual Academy exhibition could be bought and, as Rossetti never exhibited in public exhibitions, there was every danger of an impasse. In the event the resourceful Caine extracted a promise that the painting would be purchased immediately the exhibition opened and thus Rossetti's principle was only compromised for one day, after which the painting was the property of the local authority.

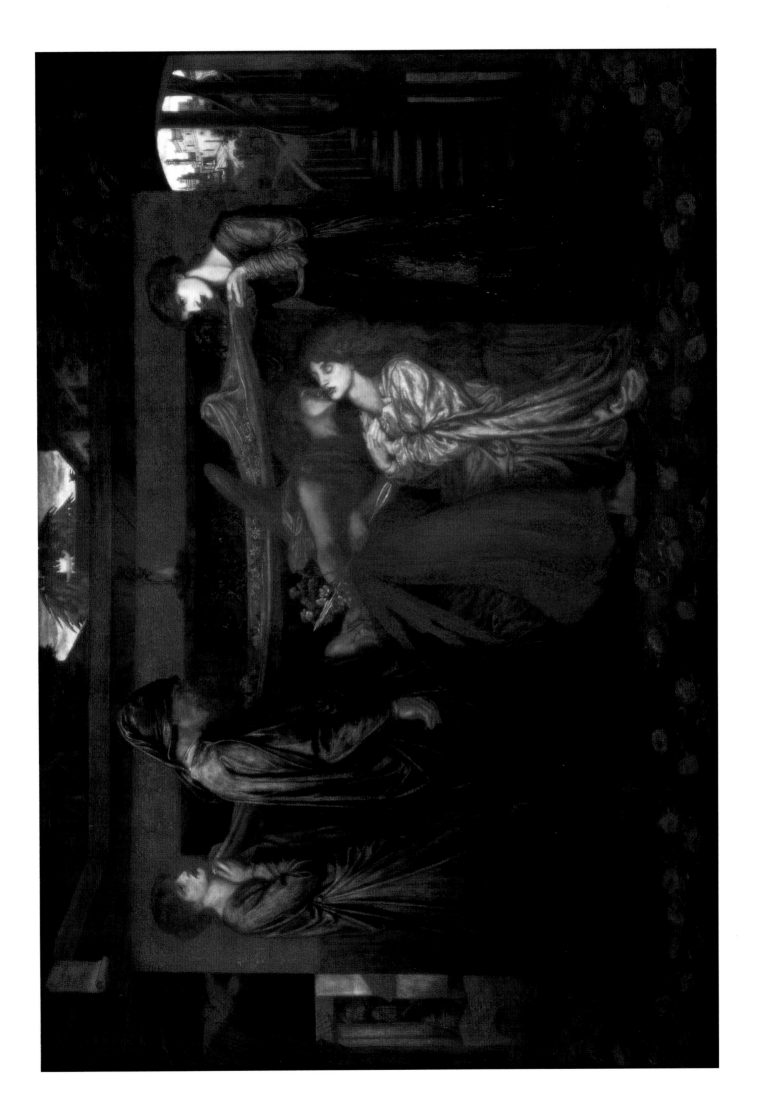

The Bower Meadow

1872. Oil on canvas, 85 x 67 cm. City Art Galleries, Manchester

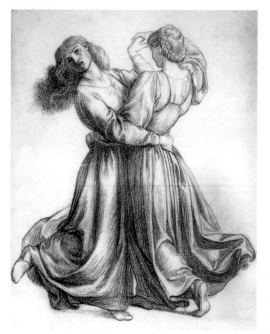

Fig. 40
Study of Dancing
Girls for The Bower
Meadow
1872. Chalk on paper,
42 x 35 cm.
Birmingham Museum
and Art Gallery

The Bower Meadow is particularly noteworthy for its landscape background which was painted from nature in Knole Park, Sevenoaks, in the company of William Holman Hunt, 22 years earlier. Rossetti had long abandoned any attempt to paint *en plein air* and, in the rare cases when more than a mere hint of landscape was required, he worked from photographs, or used studies made by assistants or friends. This landscape was originally intended to serve as the background for a painting of 'Dante and Beatrice in Paradise', which Rossetti failed to begin. His studies for the painting show that his original intention was to have the angel, now a distant figure scurrying through the meadow, in the foreground between the two musicians. At this stage both musicians faced towards the spectator in a far less sophisticated composition. In the final version Marie Spartali, on the left, wearing the familiar coiled clip in her hair, faces away from the viewer in contrast to Alexa Wilding on the right, and Rossetti may have been inspired by the success of his composition to abandon the angel for the dancing women whose pose echoes that of the principal figures in reverse. Several studies were made of the dancers who were originally drawn, according to academic practice, from the nude models with the costumes applied later (Fig. 40). Perhaps significantly the nude study was given to George Price Boyce, who was known among his circle for his appreciation of beautiful women.

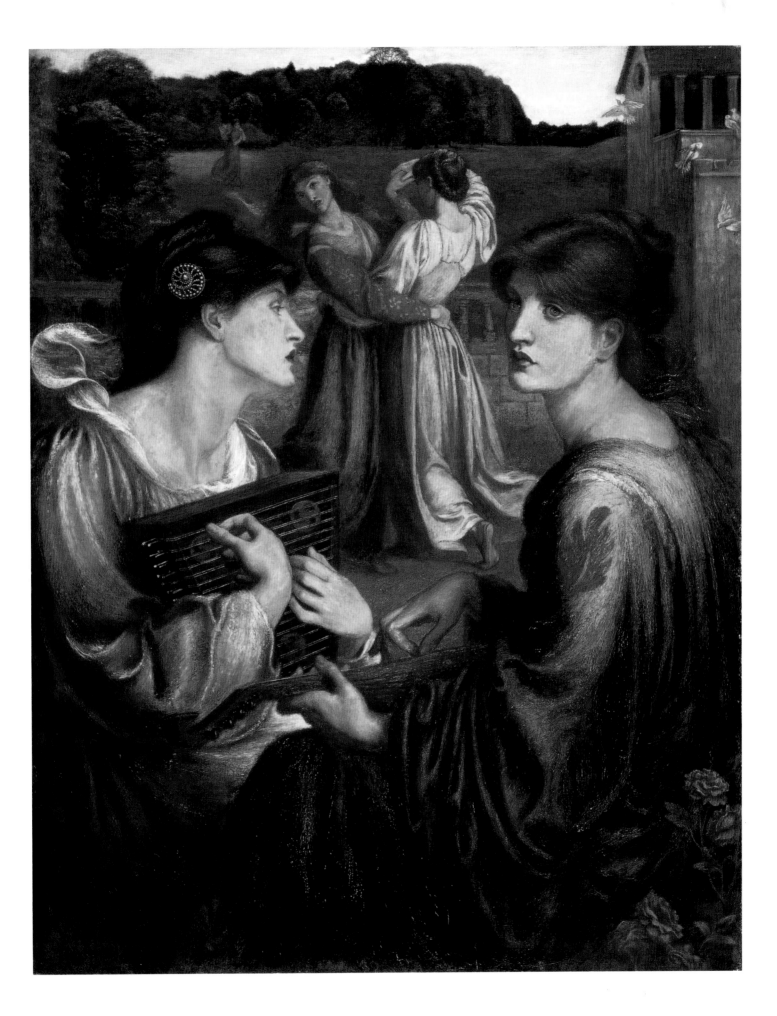

La Ghirlandata

1873. Oil on canvas, 115.5 x 88 cm. Guildhall Art Gallery, Corporation of London

As Virginia Surtees has pointed out in her *catalogue raisonné*, William Rossetti was perplexed by the apparent lack of symbolic intent in this painting, the title simply means 'The Garlanded'. It must, he surmised, have a sinister meaning, as his brother had intended to include the poisonous monkshood among the foliage but 'being assuredly far the reverse of a botanist' had substituted larkspur in error. However, in a letter to his assistant, Treffry Dunn, Rossetti simply refers to the picture as, 'that figure playing on the queer old harp which I drew from Miss W [Alexa Wilding] when you were here'.

Although meaningless, the composition is extremely decorative. The harp was an instrument much admired by the Victorians as it was considered to show female hands and wrists to great advantage. Rossetti exploits this quality in his painting, paying particular attention not only to Alexa Wilding's hands but also to those of the two angels, both of whom were taken from drawings, executed by Rossetti at Kelmscott Manor in 1871, of May, the Morrises' younger daughter, a favourite of Rossetti whom he jokingly offered to adopt. May later recorded that on one occasion 'he seriously enquired which I thought the uglier of two ladies of our acquaintance'; this was pronounced by her mother as 'very, very naughty of Mr Rossetti'.

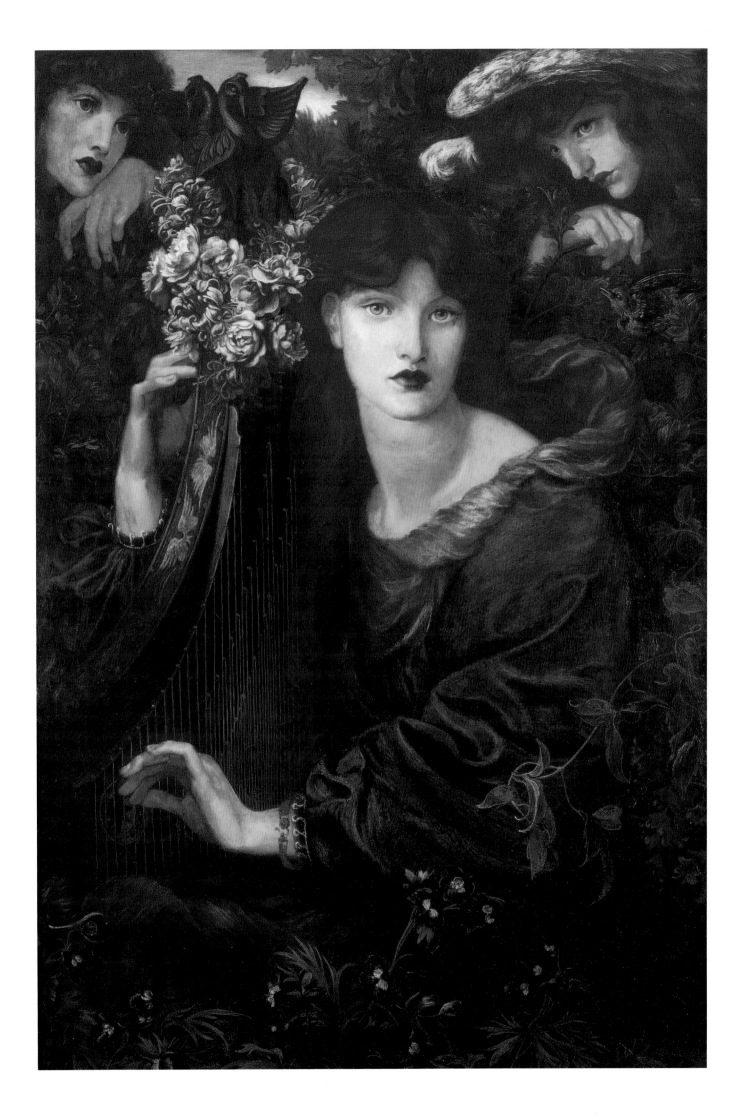

Proserpine

1874. Oil on canvas, 125.1 x 61 cm. Tate Gallery, London

Jane Morris is represented as Proserpine, the unwilling bride of Pluto, Emperor of Hades, who, by eating one seed of a pomegranate, inadvertently sacrificed the opportunity to return to earth, granted to her by Jupiter. Jane is thus portrayed once more as a woman trapped in a marriage which, in this case, is literally hellish.

Like *Beata Beatrix* (Plate 26), *Proserpine* is one of Rossetti's more haunting and compelling images and its popularity is reflected in the number of versions that patrons commissioned. In a letter to the purchaser, W A Turner, Rossetti explained that the light on the wall behind her is that of the upper world from which she has been banished, glimpsed for a moment from 'some inlet suddenly opened'. Behind her on the wall is the ivy of 'clinging memory' that also appears in *La Pia de' Tolomei* (Plate 34). There are eight versions of *Proserpine* painted between 1872 and 1882, the last being completed at Birchington-on-sea a few days before his death. For some reason Rossetti was self-consciously Italianate when painting the picture, with both the sonnet, inscribed on a scroll at the top right, and the inscription in the lower left, being in Italian.

> Afar away the light that brings cold cheer
> Unto this wall, – one instant and no more
> Admitted at my distant palace-door.
> Afar the flowers of Enna from this drear
> Dire fruit, which, tasted once, must thrall me here.
> Afar those skies from this Tartarean grey
> That chills me: and afar, how far away,
> The nights that shall be from the days that were.
>
> (From 'Proserpina', Dante Gabriel Rossetti)

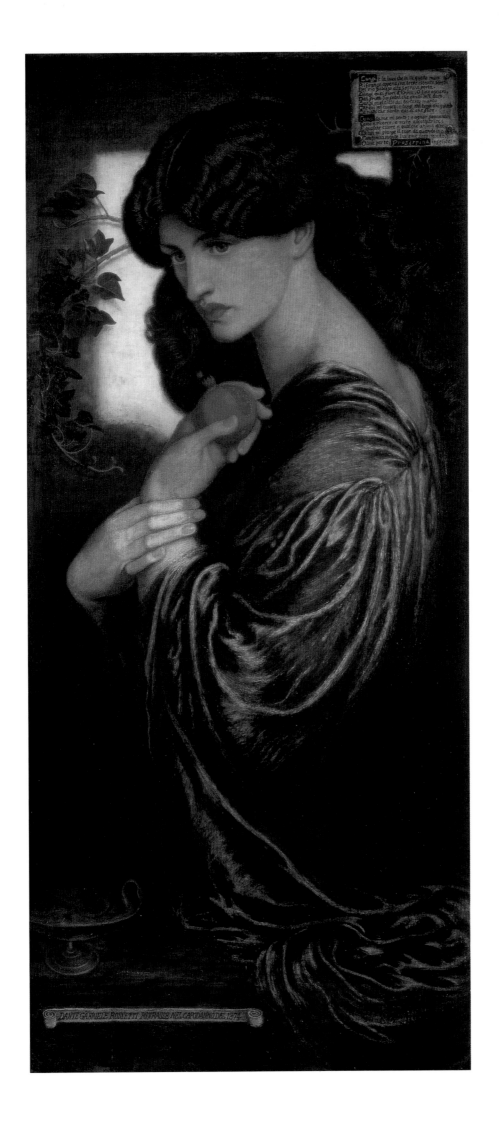

43 The Boat of Love

1874–81. Oil on canvas, 124.5 x 94 cm. Birmingham Museum and Art Gallery

The subject is taken from a sonnet by Dante, addressed to his fellow poet Guido Cavalcanti, in which, according to Rossetti, 'He imagines a pleasant voyage for Guido, Lapo Gianni, and himself, with their three ladies.' Rossetti first considered painting it around 1855, but it was not until 1871 that he suggested it to Frederick Leyland as a possible commission. His letter to Leyland is extremely enthusiastic but perhaps the suggested price, of 2,000 guineas, was a factor in Leyland's ultimate refusal, together with Rossetti's apparent inability to complete several other works that Leyland had commissioned. Rossetti spelt out the current situation in a letter of 27 February 1872:

> My Dear Leyland, Thanks for cheque £300 safely received this morning on account of the picture of 'Lady with violin'. I believe you will now find our accounts now stand as overpage – £500 received on account of large picture from Dante (Price 2,000 gns). £500 received on Lady with violin (Price 800 gns). £200 on 'La Pia' (Price 800 gns). £150 on – This last £150 we can place either to account of 'La Pia', or any next work I may do for you.

The Boat of Love was eventually commissioned by William Graham, but abandoned in 1881 after a financial disagreement. The bizarre craft in which the three poets and their beloveds are about to embark was built in the cellar of Tudor House by Treffry Dunn, and based on a boat by Benozzo Gozzoli in the Campo Santo frescos at Pisa.

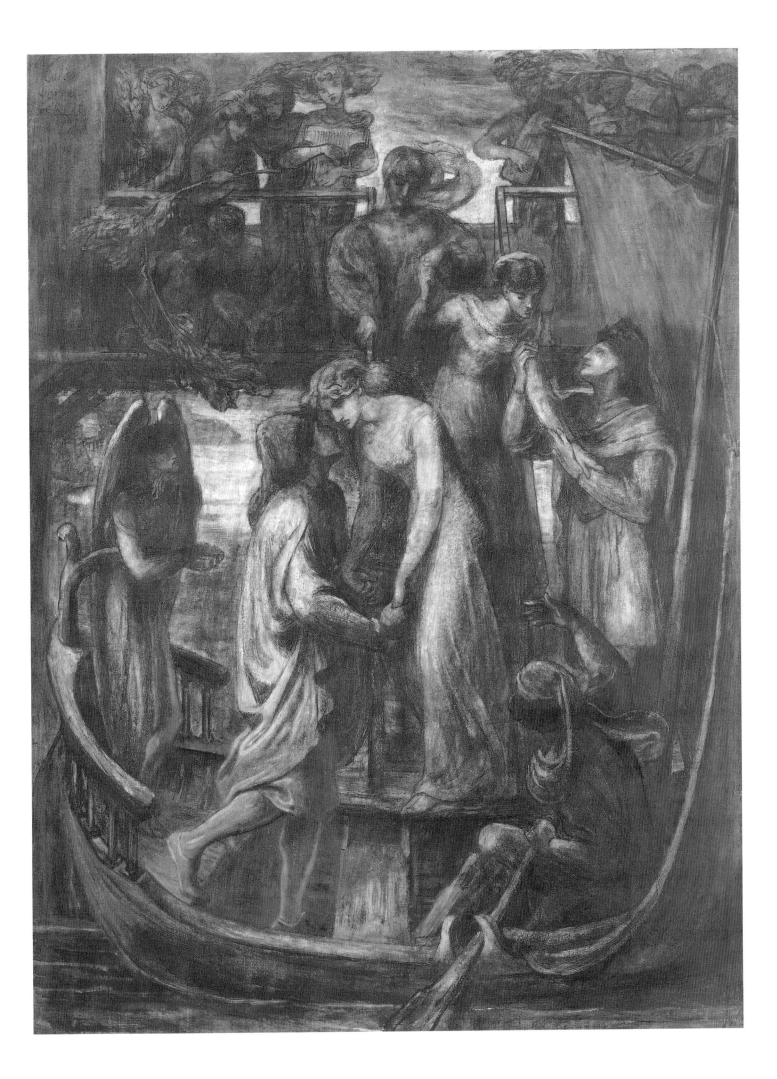

La Bella Mano

1875. Oil on canvas, 157 x 107 cm. Samuel and Mary R Bancroft Memorial, Delaware Art Museum, Wilmington, DE

The title, which means 'The Beautiful Hand' – now becoming something of an obsession in his work – would, according to Rossetti, 'remind Italian readers of the well-known Petrarchan series of sonnets, so named, by Giusto de' Conti'. The picture was commissioned by the dealer in Oriental porcelain, Murray Marks. The convex, circular mirror in the background belonged to Rossetti, who owned several like it, and in front of it to the right is the familiar coiled clip. Marks provided the tulips at great expense and the silver toilet castor below the mirror, which Rossetti had gilded to his patron's great annoyance. Alexa Wilding sat for the 'Virgin of beauty and modesty' and May Morris for both of 'Love's Attendants'. Rossetti's elevated imagery sits uneasily in a setting which, despite the trappings, is unmistakably a bourgeois Victorian interior.

> In royal wise ring-girt and bracelet-spann'd
> A flower of Venus' own virginity,
> Go shine among thy sisterly sweet band;
> In maiden-minded converse delicately
> Evermore white and soft; until thou be,
> O hand! heart-handsel'd in a lover's hand.

(From 'La Bella Mano', Dante Gabriel Rossetti)

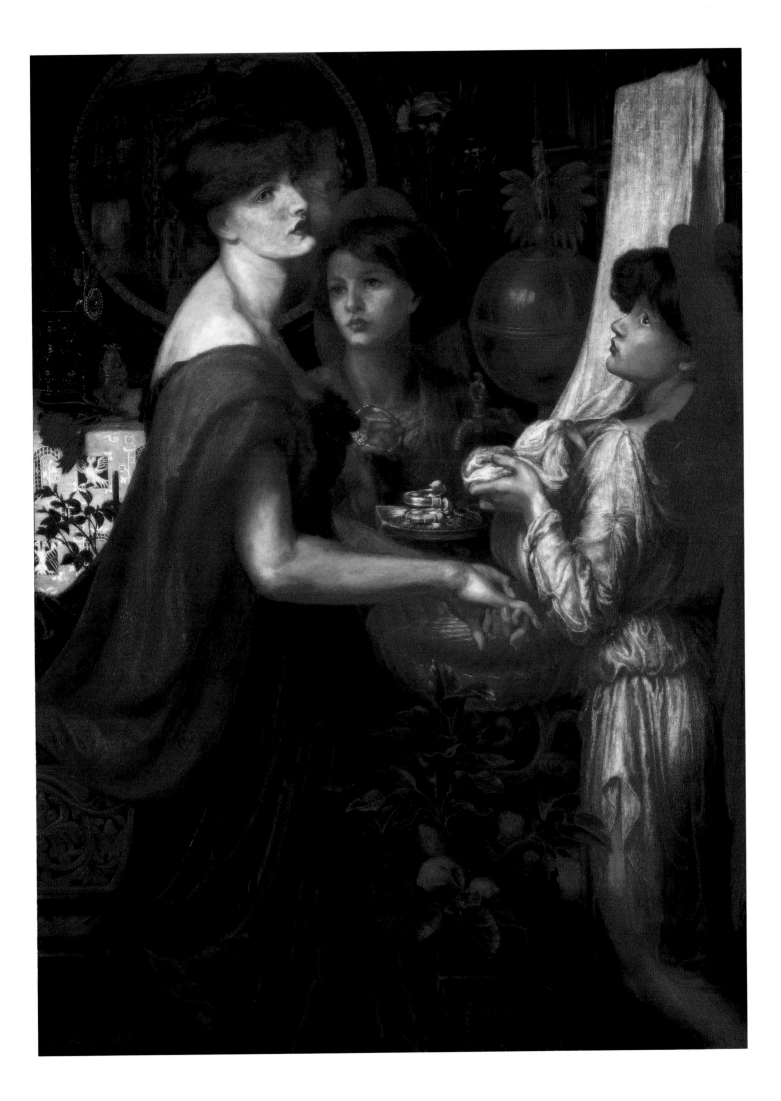

The Blessed Damozel

1875–8. Oil on canvas, 174 x 94 cm. Fogg Museum of Art, Harvard University, Cambridge, MA

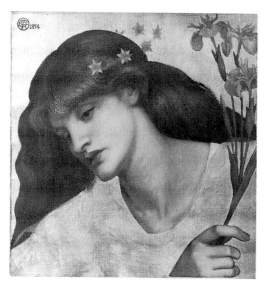

Fig. 41
Sancta Lilias
1874. Oil on panel,
48 x 45.7 cm.
Tate Gallery, London

Rossetti used his most famous poem as the inspiration for this painting 25 years after publishing the first version of it. The subject, although entirely his own invention, was inspired by Dante and deals with the theme of platonic love. The Blessed Damozel peers down from heaven awaiting her earthly lover who gazes up, unseeing, from the predella below the picture. Around her reunited lovers embrace, and below her are the heads of three angels. The heavy but integrated symbolism is typical of Rossetti's early paintings, which are contemporary with the verse. The seven stars in her hair probably signify the Seven Sacraments, and she holds a three-flowered lily, a symbol of purity and of the Holy Trinity. Alexa Wilding sat for the Damozel – 'The Blasted Damdozel' as Rossetti referred to it when faced with technical difficulties – May Morris for the angels and Wilfred Hawtry, the 18-month-old son of the local vicar, for the child-angel; Jane Morris's face is prominent among the background lovers. *Sancta Lilias* (Fig. 41), an oil study for this picture of 1874, was later gilded and given to William Cowper-Temple and his wife, in gratitude for their hospitality during Rossetti's stay at Broadlands, their country estate, in August 1876.

> The blessed damozel leaned out
> From the gold bar of Heaven;
> Her eyes were deeper than the depth
> Of waters stilled at even;
> She had three lilies in her hand,
> And the stars in her hair were seven.

(From 'The Blessed Damozel', Dante Gabriel Rossetti)

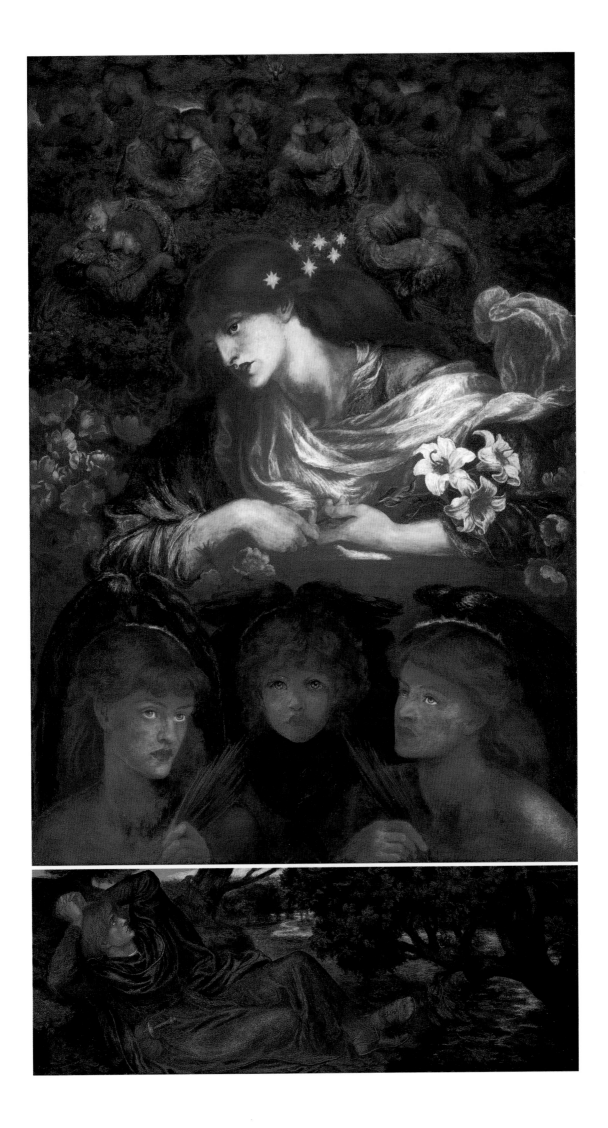

1877. Oil on canvas, 183 x 107 cm. City Art Galleries, Manchester

This extraordinary and disturbing picture reveals quite how far from the original Pre-Raphaelite principles Rossetti's genius had strayed; with the possible exception of the jasmine and the goddess's girdle, nothing in the painting shows any sign of a close observation of nature. The massive central figure, taken from Jane Morris, is mannered almost to the point of caricature, and owes an obvious debt to the work of Michelangelo (1475–1564); the pose of her right arm and hand, in particular, is remarkably similar to that of *The Dying Slave* (Musée du Louvre, Paris). Behind her two staring and startling angels look upwards against a partial eclipse. The colours of the painting are sub-aqueous and the surface is bathed in an all-pervading green. It was painted, for the most part, in Bognor in 1875 and 1876, for Clarence Fry, a partner in a photography business, for £2,100. Astarte was the goddess of fertility and love in ancient Eastern religions and was particularly important to the Phoenicians, corresponding to the Greek goddess, Aphrodite.

> MYSTERY: lo! betwixt the sun and moon
> Astarte of the Syrians: Venus Queen
> Ere Aphrodite was. In silver sheen
> Her twofold girdle clasps the infinite boon
> Of bliss whereof the heaven and earth commune:
> And from her neck's inclining flower-stem lean
> Love-freighted lips and absolute eyes that wean
> The pulse of hearts to the spheres' dominant tune.

(From 'Astarte Syriaca', Dante Gabriel Rossetti)

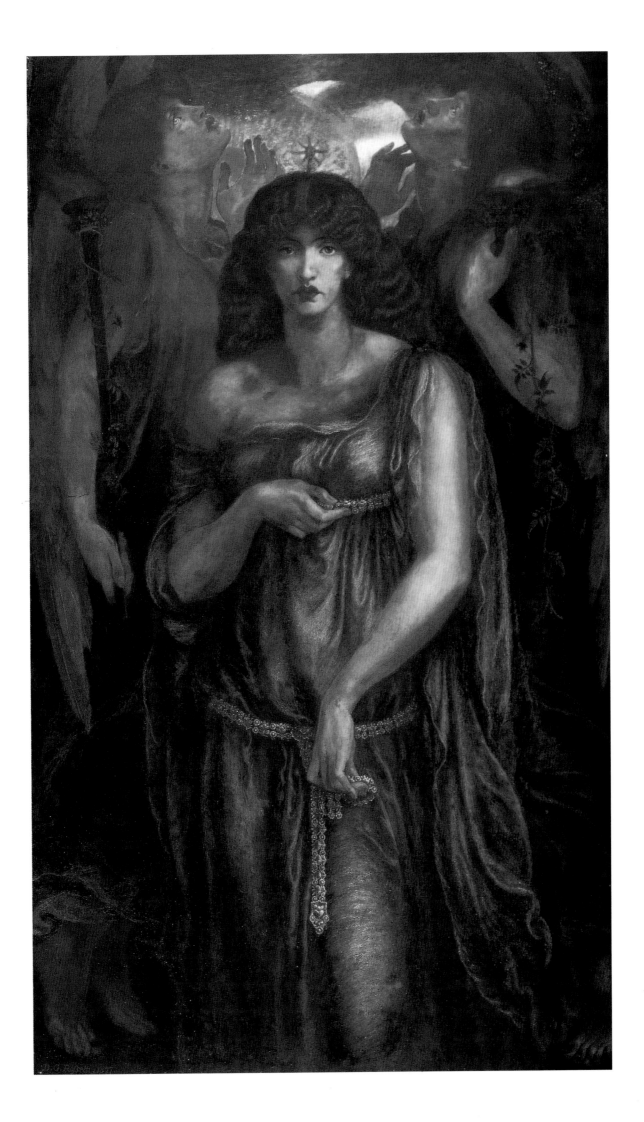

La Donna della Finestra

1879. Oil on canvas, 100 x 74 cm. Fogg Museum of Art, Harvard University, Cambridge, MA

Studies for this late picture were first made in 1870, the year in which he painted Jane Morris as *Mariana* (Plate 36) and, like that painting, its theme may have had a personal significance, although he first mentioned the subject to his godfather Charles Lyell in 1848, before he met Lizzie Siddal and long before he loved Jane Morris. The story is another taken from the *Vita nuova*, in which a woman looking down from her balcony is compassionate towards the bereaved and weeping Dante who she sees in the street below. This woman, Gemma Donati, would eventually become Dante's wife, a fantasy that Rossetti certainly entertained regarding Jane. In the following year, in a deeply moving letter which accompanied a sonnet, he wrote to her:

> The deep-seated basis of feeling, as expressed in that sonnet, is as fresh and unchanged in me towards you as ever, though all else is withered and gone. This you w'd never believe, but if life and fate had willed to link us together you w'd have found true what you cannot find to be truth when – alas! – untried.

It is possible that during the summer of 1871 at Kelmscott Jane may briefly have been tempted to leave Morris for Rossetti, but by 1874, according to her later lover Wilfrid Scawen Blunt, she found his behaviour alarming and irrational. Morris's apparent complicity in his wife's infidelities seems to have stemmed from guilt at his failure to make her happy. He was later to describe middle-class marriage as a form of licensed prostitution.

The woman sits in an open-sided loggia, the top storey of her house, a common feature in Florentine medieval palaces, and Rossetti's bottle-glass screen has again been brought into service as a window.

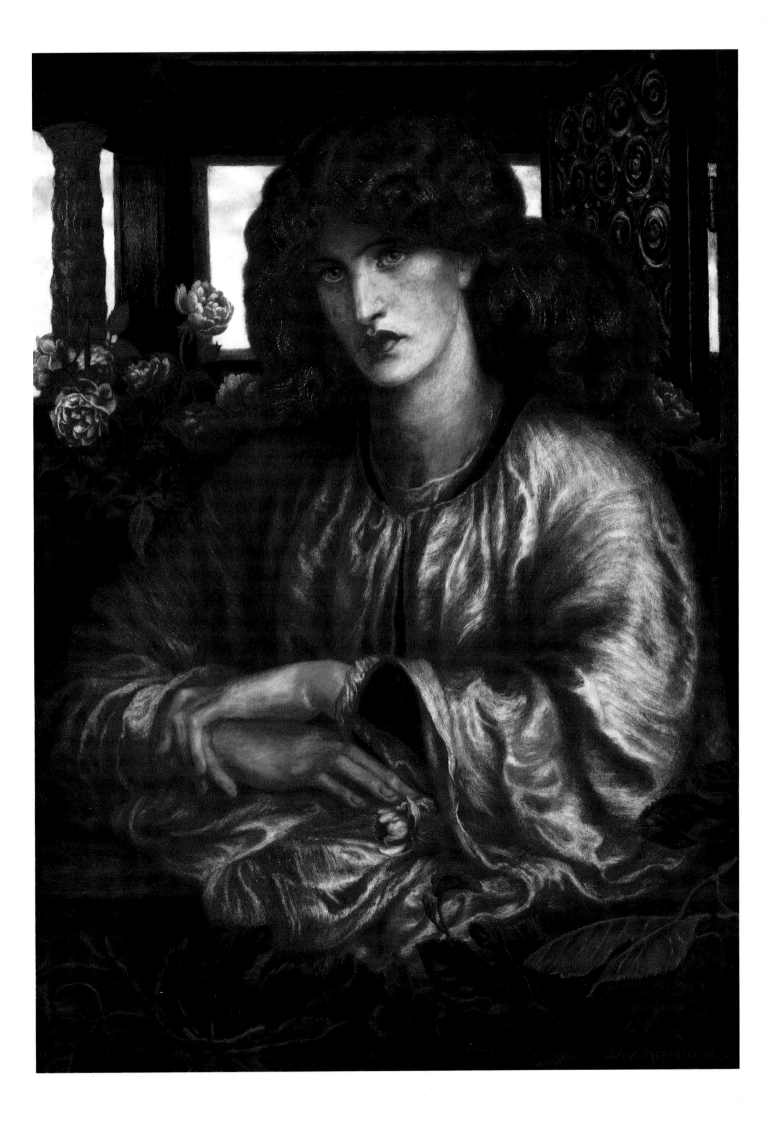

48

The Day Dream

1880. Oil on canvas, 159 x 93 cm. Victoria and Albert Museum, London

This painting was commissioned by Constantine Ionides, who saw a drawing of Jane, started in 1872 and reworked in 1878 or 1879, on Rossetti's mantelpiece when visiting Tudor House. In this painting she is sitting, slightly incongruously, in the boughs of a sycamore tree and, dreaming, ignores the book on her lap. The picture was also titled 'Monna Primavera', signifying the spring setting on which Rossetti was determined. He had great difficulty deciding the most appropriate flowers for the season and had to reject Jane's suggestion of snowdrops, which he thought too modest a flower, because they were unobtainable by the time he came to paint them. He eventually chose wild honeysuckle as 'it seems to be longer in bloom all year round than anything else'. Behind this apparently rational decision there may lie a deeper reason, as Rossetti certainly associated honeysuckle with sexual symbolism. In a letter to Jane during the painting of *The Day Dream*, he expressed his sorrow that the foot was painted from another model.

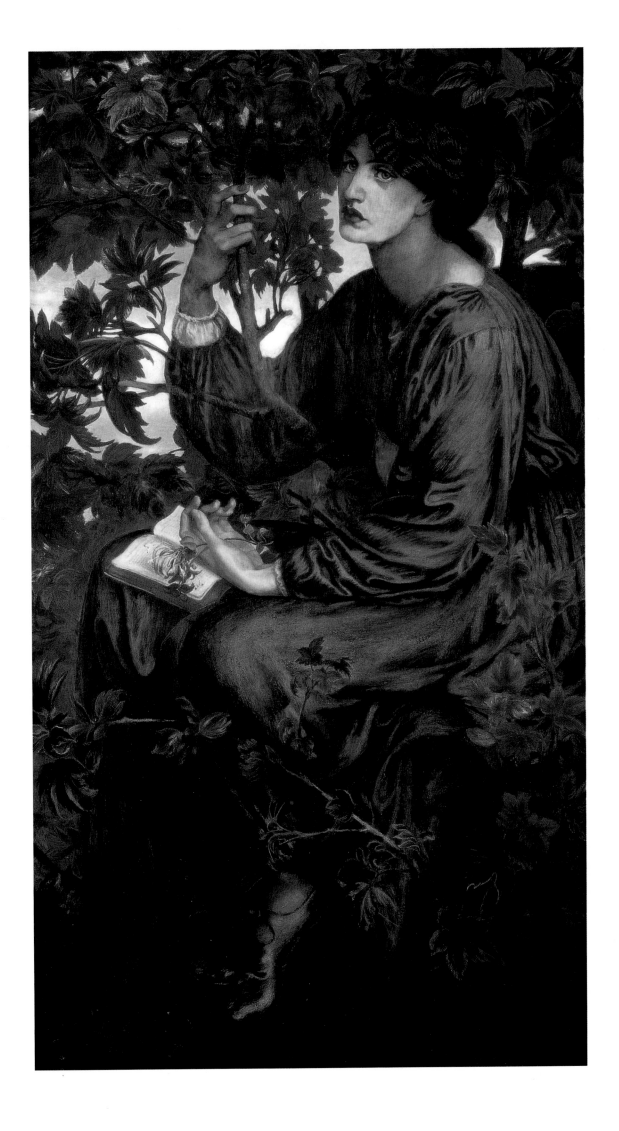

PHAIDON COLOUR LIBRARY
Titles in the series

| FRA ANGELICO | BONNARD | BRUEGEL | CANALETTO | CARAVAGGIO | CEZANNE | CHAGALL | CHARDIN | CONSTABLE |
| Christopher Lloyd | Julian Bell | Keith Roberts | Christopher Baker | Timothy Wilson-Smith | Catherine Dean | Gill Polonsky | Gabriel Naughton | John Sunderland |

| CUBISM | DALÍ | DEGAS | DÜRER | DUTCH PAINTING | ERNST | GAINSBOROUGH | GAUGUIN | GOYA |
| Philip Cooper | Christopher Masters | Keith Roberts | Martin Bailey | Christopher Brown | Ian Turpin | Nicola Kalinsky | Alan Bowness | Enriqueta Harris |

| HOLBEIN | IMPRESSIONISM | ITALIAN RENAISSANCE PAINTING | JAPANESE COLOUR PRINTS | KLEE | KLIMT | MAGRITTE | MANET | MATISSE |
| Helen Langdon | Mark Powell-Jones | Sara Elliott | J. Hillier | Douglas Hall | Catherine Dean | Richard Calvocoressi | John Richardson | Nicholas Watkins |

| MODIGLIANI | MONET | MUNCH | PICASSO | PISSARRO | POP ART | THE PRE-RAPHAELITES | REMBRANDT | RENOIR |
| Douglas Hall | John House | John Boulton Smith | Roland Penrose | Christopher Lloyd | Jamie James | Andrea Rose | Michael Kitson | William Gaunt |

| ROSSETTI | SCHIELE | SISLEY | SURREALIST PAINTING | TOULOUSE-LAUTREC | TURNER | VAN GOGH | VERMEER | WHISTLER |
| David Rodgers | Christopher Short | Richard Shone | Simon Wilson | Edward Lucie-Smith | William Gaunt | Wilhelm Uhde | Martin Bailey | Frances Spalding |